MW00826605

TVA Photography, 1963–2008

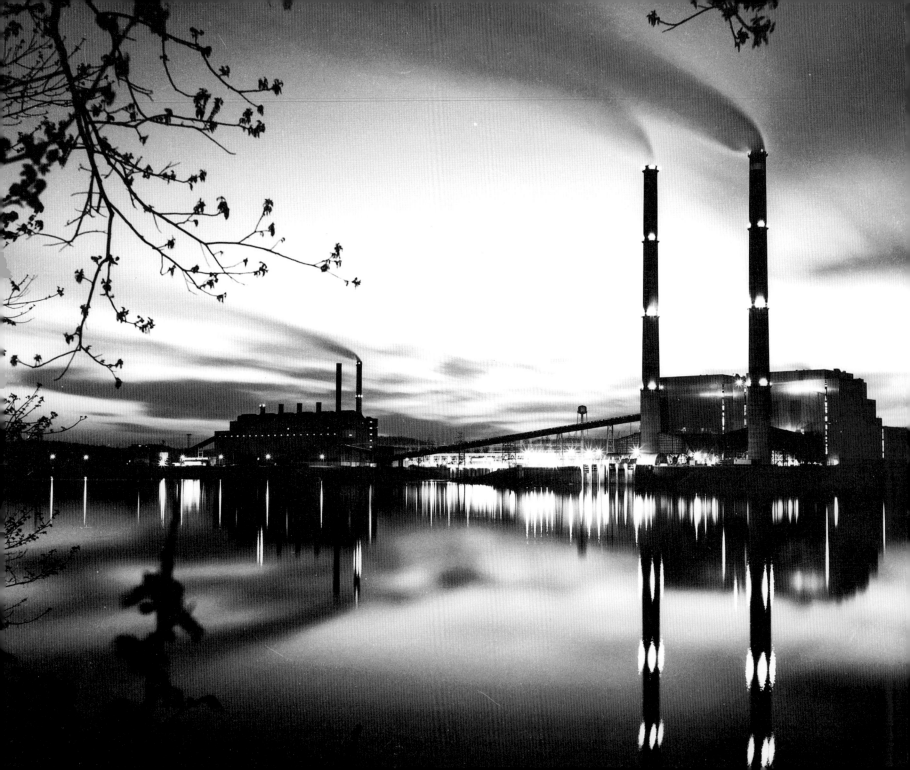

TVA Photography, 1963–2008

CHALLENGES AND CHANGES IN THE TENNESSEE VALLEY

 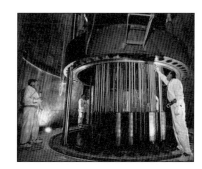

Patricia Bernard Ezzell

UNIVERSITY PRESS OF MISSISSIPPI / *JACKSON*

www.upress.state.ms.us

Typeset by Peter Halverson

The University Press of Mississippi is a member of the Association of
American University Presses.

Copyright © 2008 by University Press of Mississippi
All rights reserved
Manufactured in the United States of America

First printing 2008
∞
Library of Congress Cataloging-in-Publication Data

Ezzell, Patricia Bernard.
TVA photography, 1963–2008 : challenges and changes in the
Tennessee Valley / Patricia Bernard Ezzell.
p. cm.
Includes bibliographical references and index.
ISBN 978-1-60473-083-8 (cloth : alk. paper) —
ISBN 978-1-60473-084-5 (paper : alk. paper) 1. Tennessee Valley
Authority—History. 2. Tennessee Valley Authority—Pictorial works.
I. Title.
TK1425.M8E982 2008
779'.933391409768—dc22 2008004320

British Library Cataloging-in-Publication Data available

Dedicated to all TVA employees—past, present, and future

Contents

Foreword IX

Acknowledgments XI

Introduction 3

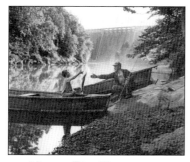

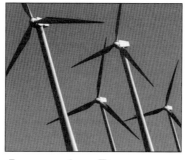

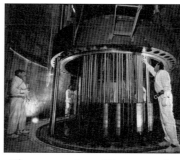

New Challenges
1963–1978

{ 35 }

Increasing Pressures
1979–1992

{ 91 }

Competing Demands
1993–2007

{ 135 }

Notes 177

Bibliography 181

For Further Reading 187

Index 189

Foreword

Just as a Greek philosopher observed that one can never set foot in the same river twice because it is constantly changing, so it is for the Tennessee Valley Authority. The TVA that our parents and grandparents worked for and were served by is not the same TVA that we know today. But just like a flowing river, the original mission of TVA remains the same—to help improve the quality of life for the people of the Tennessee Valley.

While the river and TVA are constantly changing, we do have the benefit of photography to capture images that illustrate the milestones of TVA history. Through these images, we can see, frozen in time, the moments in the never-ending progress as the people of TVA work diligently each day to build a better future for their friends and neighbors—and the next generation of the Tennessee Valley.

A constant theme in TVA's history is that the sum of its contributions to the Tennessee Valley region is far greater than each of those parts taken on its own.

The images from TVA's history show us how its work in the valley enables progress in ways that build on and enhance each other. We see dams built to tame wild rivers. We see communities that can grow and thrive without the threat of devastating annual floods. We see the benefits of modern life brought to remote farms. We see a navigation system linking once inaccessible areas to ports around the world and bringing industries and jobs. We see beautiful reservoirs for recreation.

Not long after I joined TVA in 2005, I saw a pictorial history that covered the years from its creation in 1933 through its thirtieth anniversary. As we approached the celebration of TVA's seventy-fifth anniversary in 2008, I suggested that Patricia Bernard Ezzell should use her talents and knowledge of TVA's history to capture the progress and changes that TVA has made since 1963.

This book covers the decades following TVA's initial success in building a hydroelectric and fossil-fueled power system that helped transform a largely agricultural region into one of our nation's thriving centers of industry and manufacturing.

Moving into the modern era, TVA helped pioneer the first generation of commercial nuclear power plants, expanded the power system to meet the needs of an ever-growing region, and began the transition to meeting the challenges of a more competitive electric utility marketplace.

Today, the people at TVA are using the technologies of the computer age to produce electricity more efficiently and more reliably than was ever thought possible seven decades ago. The same technological advances are also used to help cities and communities strengthen the region's economy and to maximize the value and environmental quality of the river and the adjoining watersheds that make the valley a desirable place to live, work, and raise a family.

The people at TVA understand that their work is more than just a job—it's a commitment to fulfill a noble mission that continues to benefit an entire region and our nation.

Tom Kilgore
President and Chief Executive Officer, TVA
December 2007

Acknowledgments

Every book has a story of how it came to be. This volume is no different. In 2003 the University Press of Mississippi published *TVA Photography: Thirty Years of Life in the Tennessee Valley*, a project that highlighted TVA's accomplishments, and its collection of excellent photographs, from the period 1933 to 1963—a project I had worked on for many years. One morning in 2005, I arrived at my cubicle in TVA's Knoxville offices to find a Post-it note stuck on my desk. It read, "Pat, Mr. Kilgore saw your photo book and really liked it! Now he wants 1963 to the present. Let's talk—Bridgette." That simple note led to this project, but no project can be completed without the support and assistance of family, friends, and colleagues.

First of all, I must thank Tom Kilgore, TVA's president and chief executive officer. His interest in the more recent history of TVA made this project possible. Kate Jackson and Bridgette Ellis supported, encouraged, and reviewed this work, as did Dan Ferry, Bennett Graham, and Tom Maher.

Nancy Proctor, librarian at the TVA Research Library in Knoxville, always provided her assistance and knowledge in the most cheerful manner, and my friend and former colleague, Mary Jane Lowe, now a librarian working in Colorado, sent articles over the Internet faster than anyone I know. Arlene Royer and Rob Richards of the National Archives in Atlanta answered questions and provided information from the vast amount of records stored at their facility. Ed Frank, curator of special collections at the University of Memphis, graciously honored my request for several oral history interviews.

Bob Kollar, Cletus Mitchell, Mike Biddle, Todd Winkler, and Nancy Cann all helped find some of the more recent TVA photography, and Ed Thompson and the staff at Thompson's Photo Products in Knoxville

provided their professional lab services once again. I must give special thanks to Mark McNeely, who scanned the negatives and prints, always with a smile and always with "sure, I can do one more." Garry Pyle, helpful as always, gave expert technical advice. Catherine Mackey read the draft and several revisions and provided excellent comments, while Barbara Martocci helped with clarification as she lent her outstanding communications skills.

In the course of other tasks, I have had the opportunity to bounce ideas off former TVA employees including Phil Mummert, Maxwell Ramsey, and Dick Swisher. Craig Gill of the University Press of Mississippi provided his expertise with the publishing world, and Maury Klein offered his friendship and support.

Also giving support in numerous ways throughout the process were my co-workers on the cultural resources staff: Erin Broyles, Greg Broyles, Bob Cavendar, Michaelyn Harle, Eric Howard, Jack Muncy, Sharon Nix, Danny Olinger, Chett Peebles, Erin Pritchard, Jon Riley, Marianne Shuler, Kathleen Stringfield, Charles Tichy, Ted Wells, and Richard Yarnell. Sidney Schaad, another co-worker, lent his keen eye and his support, too.

Parents always believe that their children can do anything, so let me thank Elmer and Della Bernard for always believing. I must thank my children, Will and Sophie, for their ability to be quiet when I was working at home and for their infinite patience ("Don't you have that done yet, Mom?"). And finally, a most heartfelt thanks I give to my husband, Tim, for lending his editing skills, his patience, and his constant reassurance that everything will turn out fine.

TVA Photography, 1963–2008

Introduction

On May 18, 1963, President John F. Kennedy visited three cities on a whirlwind trip through the South. That morning he stopped in Nashville, Tennessee, to recognize the ninetieth anniversary of Vanderbilt University. He next traveled to Muscle Shoals, Alabama, where he joined the celebration of TVA's thirtieth anniversary. Kennedy's day ended with a visit to Huntsville's Redstone Arsenal to applaud the scientific work taking place there. By all accounts, at every location that day, the crowds were warm and the sun was hot.[1] At the anniversary ceremonies, President Kennedy spoke eloquently about TVA's past. He highlighted how the agency "transformed a parched, depressed, and flood-ravaged region into a fertile, productive center of industry, science, and agriculture."[2] The president then told the throng assembled at Muscle Shoals that "in the minds of men the world over, the initials TVA stand for progress, and the people of this area welcome progress."[3]

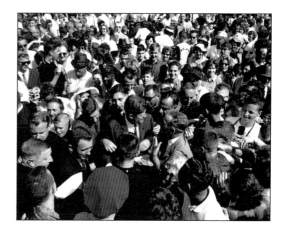

By 1963, thirty years after the creation of the regional development agency, the people of the valley had welcomed progress with open arms. Partnering with state and local governments and other federal agencies, TVA had transformed the Tennessee Valley.[4] A virtual stairway of nine dams and reservoirs provided

President John F. Kennedy visits Muscle Shoals, Alabama, on the occasion of TVA's thirtieth birthday. A crowd of fifteen thousand turned out to hear his remarks. May 18, 1963. (KX-5554)

a continuous nine-foot river navigation channel permitting the movement of more than 13 million tons of commercial freight traffic annually. TVA's multiple-use reservoir system also provided 12 million acre-feet of water storage, making serious floods a thing of the past.

By the early sixties, average annual home use of electricity in the TVA region exceeded ten thousand kilowatt-hours per customer, a dramatic contrast with six hundred kilowatt-hours per customer in 1933. TVA generated forty-six times as much power in 1963 as it did in 1933—power used in homes, on farms, in business and industry.[5]

The agency, which began work in the 1930s on one fertilizer, concentrated superphosphate, produced large quantities of ten different kinds of fertilizer by 1963. Educational programs, such as test-demonstration farms and fertilizer distributor demonstrations, employed TVA fertilizers in forty of the fifty states in cooperation with land grant agricultural colleges and industry. TVA also loaned agriculturists and chemical engineers to the Agency for International Development, allowing TVA's work in fertilizer research to reach a global audience. The agency had also provided more than 570 million seedlings for reforestation, restoring large tracts of the southern landscape. In fact, TVA was so successful that it attracted interest abroad, and was widely regarded as the model for transforming developing countries. An estimated 30,000 foreign visitors came to the Tennessee Valley between 1945 and 1963 to study and experience the agency's programs. In 1963 alone, TVA hosted 2,597 visitors from eighty-eight nations.[6]

But while President Kennedy highlighted the achievements of the past, he also spoke of TVA's future:

Finally, there are those who say that TVA has finished its jobs and outlived its challenges. But all of the essential roles of TVA remain. Their importance increases as the importance of this area's atomic energy, military, and commercial activities increase, and new opportunities, new frontiers open every year, including work on the smaller upstream tributaries, reclaiming land scarred by coal mining, new types of national recreational areas, and new studies of flood land zoning and planning, to name a few. In short, the work of TVA will never be done until the work of our country is done.[7]

TVA's future, as well as that of the country, could not have looked more promising on that hot spring day. The coming months, however, brought the young president's assassination and the end of the New Frontier, leaving the country on the verge of major social upheaval. In the midst of this national climate of uncertainty, TVA continued its mission to improve the quality of life for the people of the Tennessee Valley. In an effort to fulfill this mission, TVA would, in the coming years, narrow its institutional vision and emphasize power production over other programs. "Electric energy" was, in the words of TVA's Director of Information Paul Evans, "the one element which encompassed everything and which touched on everybody's life—better living, better jobs, industrialization of the Valley, the better use of the Valley's resources."[8]

Yet, in the 1960s and 1970s, as the world around the agency was changing, TVA's institutional culture remained largely unchanged, and agency leaders seemed, at times, oblivious or unmoved by political and cultural upheaval. This inability to adapt to the changing external environment contributed to the public's shifting perception of TVA. Although the agency had once been a very popular and trusted organization, the public's opinion of it changed to one of distrust and disillusionment.[9] Often TVA's policies ran counter to prevailing sentiments and put the agency at odds with the people it was trying to help. Fortunately, through all of the challenges, changes, and controversies, TVA kept photographers on staff. Their images, as illustrated in this volume, document TVA's continued legacy to the region, nation, and the world. They also, however, bear witness to the transformation of the agency, as TVA changed from an experiment in public administration to an established public utility.

The Tennessee Valley Authority, 1964–Present

In 1964, the agency's focus remained on unified resource development in the Tennessee Valley region. Freight shipped on the Tennessee River totaled nearly 15.4 million tons, 6 percent above 1963 and a record for the third straight year. Flood control in March and April of 1964 thwarted approximately $1 million in damage at Chattanooga, Tennessee, bringing damages averted at that point to $252 million, an average of $8.7 million a year since 1936. Residential use of electricity continued to increase, and rates remained low—less than one

cent per kilowatt-hour as compared with the national average of 2.3 cents per kilowatt-hour. Agricultural and fertilizer research continued to be a major responsibility. TVA's test-demonstration farm program introduced new fertilizers, encouraged better fertilization practices, and improved products, manufacturing processes, and methods of fertilizer distribution across thirty-one states. TVA also established fourteen rapid adjustment test-demonstration farms which showed how farm enterprises might be improved and income increased. In total, TVA distributed about 250,000 tons of ten different fertilizers in these demonstration programs.[10]

While work continued in these mainstay areas, other TVA programs, such as recreation, tributary area development, and fish and wildlife management, increasingly gained recognition and importance.[11] The most visible example of this policy shift can be seen in the development of the agency's Land Between the Lakes project (LBL). In 1961, TVA proposed to President Kennedy that "the lower Cumberland and Tennessee Rivers be established as a national recreation area in support of the country's present and future need for outdoor recreation properties."[12] The project location, in western Kentucky and Tennessee, was selected as a national recreational area in part because it was within a day's drive of 70 million people, many of whom lived in industrial cities in the East and Midwest.[13] In June 1963, President Kennedy approved the 170,000-acre project, and Congress appropriated dollars for LBL in the Public Works Appropriations Act of 1964. TVA owned 67,000 acres of the property and acquired an additional 103,000 acres, forcing the relocation of approximately nine hundred families. In all some twenty-seven hundred residents from the communities of Model, Blue Spring, Hays, and Mint Spring in Tennessee and from Fenton, Golden Pond, Hematite, and Energy in Kentucky were moved from their land and homes.[14]

Despite these controversial measures, LBL was a new and significant step in the demonstration of outdoor recreation possibilities, and was viewed, for the most part, as successful. The development exemplified how an area with limited timber, agricultural, and industrial resources could be converted into a recreation asset that would stimulate economic growth of the region. Fishing, hunting, sailing, camping, and picnicking had enormous appeal. TVA's ultimate development of the area included a variety of facilities and programs which allowed large numbers of individuals, families, and members of organized groups to enjoy the area's woodlands, fields, and three hundred miles of winding, varied shoreline along two reservoirs. Activities ranged

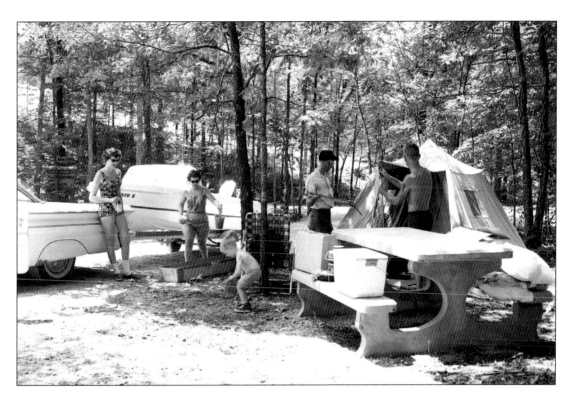

from camping at developed sites and wild areas, upland hunting, and water sports to the educational aspects of natural and cultural resources management.[15]

Besides developing new recreation areas, TVA placed growing emphasis on the Office of Tributary Area Development (TAD). The agency operated under the premise that for progress to be made on the local level, attention would have to be given to the more remote tributary regions. To do this, TVA specialists worked closely with community leaders and volunteers to stimulate economic development and im-

Camping at Rushing Creek Campground, the first campground to open at TVA's Land Between the Lakes (LBL) National Recreation Area. Pictured are the Frank Grace and Maurice Thompson families of Hopkinsville, Kentucky, some of the first visitors to enjoy the new campground. About eighty campers were there the first weekend, and facilities were ready for up to one thousand campers by midsummer. June 6, 1964. (KX-5841)

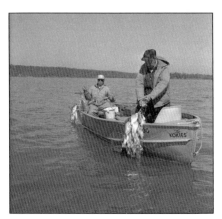

prove the quality of life through specific programs tailored to meet local needs. Projects included the development of adult education and job training programs, planning of water and sewer systems, initiation of health education programs, building of water control structures, implementation of intensive farm management and agricultural development programs, and establishment of garbage collection and disposal programs.[16]

The communities also benefited from technical assistance in the field of flood control. TVA created plans and local ordinances to restrict development in the floodplains and to help mitigate inundation costs and damages. The floodplain management program discouraged construction in low-lying areas and urged communities instead to reserve such areas for recreation and other low-risk uses. The program, which helped more than 120 communities address flooding issues, proved successful and later served as a model for a nationwide program administered by the U.S. Army Corps of Engineers.[17]

The agency also recognized fish and wildlife as important economic assets. TVA noted that these natural resources created jobs for the thousands who provided services for fishermen, hunters, and other recreational users. The agency argued that, as with other resources, fish and wildlife must be protected, managed, and sustainably utilized. TVA noted that the expenditures of sport fishermen alone helped stimulate a $53 million investment in facilities such as boat docks, ramps, and fishing camps. Commercial fishing and musseling also contributed over $2 million to the valley's economy.[18]

The appreciation of nature, however, extended beyond the region's sportsmen. Environmental awareness and ecological concerns were increasingly apparent in the Tennessee Valley through the 1960s and 1970s.[19] At that time, young Americans, especially those in colleges and universities, began to question their parents'

(*Top*) Composting project at Johnson City, Tennessee. April 8, 1970. (KX-9207) (*Bottom*) Fishing on Kentucky Reservoir. Fishing has always been a favorite pastime in the Tennessee Valley. In the early 1970s, TVA estimated that 850,000 fishermen spent $42 million a year in the Tennessee Valley, virtually all of which was going to local merchants for bait, boats, gasoline, tackle, and other supplies. April 1, 1972. (KX-10325)

values and joined in movements to redress perceived inequities in American society. The civil rights movement, which had already caused much tension in the southern states, worked to eliminate discrimination against African Americans and to expand opportunities available to them. The Civil Rights Act of 1964 prohibited discrimination in public places, provided for the integration of schools and other public facilities, and made employment discrimination illegal. A related reform measure sought to achieve equality for women, who had long been considered second-class citizens. Latinos and Native Americans also sought equal rights.[20]

Inspired by the success of these movements, environmental advocates adopted similar tactics. As Americans became aware of the effects of pesticides and industrial waste upon the natural environment, they vocalized demands for change. The first Earth Day in 1970 celebrated the world's natural resources and highlighted continuing threats. This reform movement also led to new legislation and the creation of the Environmental Protection Agency.[21]

The growing debacle in Vietnam shattered America's confidence in its mission and its might, and led to a widespread debate about what role the United States should play in the larger world. The Watergate scandal further disillusioned the public and strained the government.[22] In fact, one historian wrote that in the 1970s "Americans developed a deeper, more thorough suspicion of the instruments of public life and a more profound disillusionment with the corruption and inefficiency of public institutions."[23] Political, social, and economic controversy had replaced complacency, and this change was apparent everywhere—including the Tennessee Valley. TVA, however, remained remarkably insulated from the surrounding transformation. The agency persisted as a postwar bureaucracy and was dominated by technocrats who, hardened by the youthful experiences of depression and war, were often dismissive of societal changes. As TVA's former director of information, Paul Evans, noted, "the new environmentalists . . . were a different generation than the generation that was running TVA." Evans explained that the "new environmentalists had never known bread lines and unemployment . . . and weren't even sure these dams should have been built."[24] As a result, TVA's institutional culture was increasingly at odds with the prevailing political and social culture, and the agency, once seen as promoter of progress, was now viewed as a barrier to positive change.

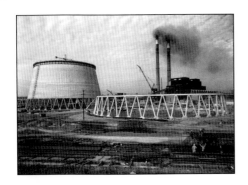

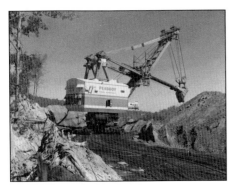

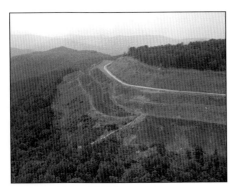

Nowhere was this disconnect more evident than in the area of environmental policy. One of the first controversial environmental issues that TVA faced involved strip mining. By the early 1950s, TVA had discovered that the demand for electricity was outpacing the capacity of the dams and the river system to produce it. As a result, the agency began building coal-fired steam plants, and, by 1955, coal surpassed hydropower as its system's primary source of power.[25] By the late 1960s, more than 2 million consumers were using electricity, and average use had climbed to nearly fourteen thousand kilowatt-hours—two hundred times more than in 1933.[26] By 1969 coal-fired power plants supplied nearly 80 percent of TVA's 18 million kilowatt generating capacity.[27] As demand for electricity increased, so did the demand for inexpensive coal to fuel TVA's steam plants. This demand, along with the development of giant earth-moving machinery, resulted in expanded strip mining.[28] Because the effects of strip mining were so visible, critics charged that TVA was neglecting its stewardship responsibilities.[29]

One of the more eloquent critics regarding TVA's coal policy was Harry Caudill, Kentucky legislator and attorney, who authored the seminal work *Night Comes to the Cumberlands*. Caudill agreed that for many years TVA "was a benevolent government agency" dedicated to public service. But, according to Caudill, a subtle change came over the TVA. "By degrees it changed direction, converting into a mammoth corporation which subordinated all other considerations to low costs and balanced budgets."[30] As he saw it, "T.V.A., the mighty benefactor of the Tennessee Valley, has become a gigantic co-partner in the destruction of the Cumberland Plateau . . . T.V.A. has been able to boast of its cheap and stable charge schedule. Other

(*Top*) Paradise Steam Plant, Paradise, Kentucky. Unit 3 construction area in foreground. January 16, 1967. (64P1582) (*Middle*) Peabody Coal Company, Kentucky. Peabody shovel holds 125 cubic yards. May 25, 1971. (KX-10082) (*Bottom*) Massengale Mountain, Campbell County, Tennessee, Long Pit Mine, strip mine reclamation. June 23, 1976. (GR-76124)

producers of electric power have struggled to remain reasonably close to its price level. Their consumers have been convinced that in cheap electricity they are receiving the best bargain afforded by the American industrial machine. . . ."[31] Caudill argued persuasively that future generations would bear the cost of cheap, abundant electric power.[32]

TVA responded to Caudill and other detractors by establishing demonstrations of strip mine reclamation methods and urged passage of effective reclamation laws at the state level. However, the agency refused to stop buying strip-mined coal. Management reasoned that if TVA did not buy this coal, others would, and the environmental problems would persist unabated. In an effort to promote better mining practices, TVA in 1965 began including a requirement in its contracts that strip-mine suppliers restore and revegetate the affected natural area.[33] Though this requirement preceded state actions to improve environmental conditions, the agency continued to be perceived as a threat to the region's environmental health.

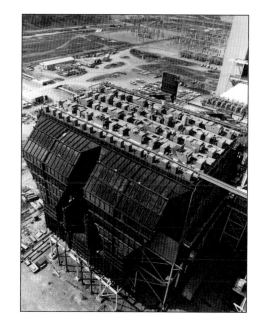

Concerns related to air quality further eroded the agency's environmental reputation. The cheap electric power that attracted industry to the Tennessee Valley had become a major source of air pollution. When Congress passed the Clean Air Act in 1970, TVA had sixty-three coal-generating units in twelve plants in Kentucky, Alabama, and Tennessee.[34] To address growing air quality concerns, the agency installed electrostatic precipitators to control ash and soot particles emitted from the coal-fired steam plants. In 1978, TVA and the Environmental Protection Agency agreed on a plan that would allow the utility to use the least expensive measures to meet the strict air quality control standards at each plant. These measures included replacing high-sulfur coal with lower-sulfur coal, restricting some maximum generating levels, and adding scrubbers, which removed sulfur dioxide from steam plant emissions.[35]

Electrostatic precipitators, Bull Run Steam Plant. This equipment is part of TVA's air pollution program for controlling fly ash emissions at all of its coal-fired power plants. At completion, the total valley-wide investment of this program exceeded $300 million. May 16, 1977. (GR-77087)

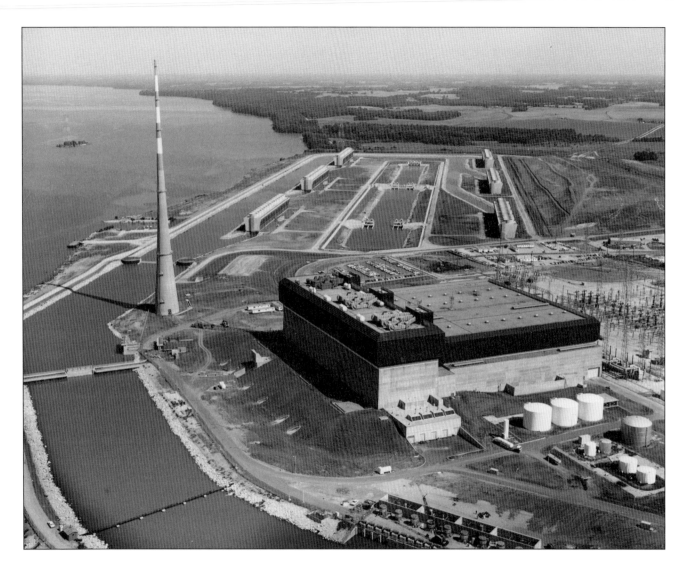

Aerial view of TVA's Browns Ferry Nuclear Plant near Athens, Alabama. The first nuclear plant to begin operation in the TVA power system, Browns Ferry was the largest nuclear plant in operation anywhere. Its three units have a total generating capacity of 3.3 million kilowatts of electricity. The first unit at the plant began operation in 1974. May 12, 1977. (GR-77116)

Partly because of the challenges associated with widespread coal use, and because of massive projected energy demands, TVA explored other methods for generating electricity. During the late 1960s, TVA began a program to supplement its hydroelectric and fossil-fueled plants with nuclear energy. In 1967 in north Alabama, TVA began construction of Browns Ferry, the agency's first nuclear-powered plant. The first of many TVA rate increases, caused by rising coal, labor, and interest costs, also occurred in 1967. The environmental problems associated with coal were becoming more apparent, while nuclear energy was perceived to be an economical, environmentally sound method for generating electricity. Commercial operation of Browns Ferry in 1974 allowed TVA to enter the nuclear age.[36] By the time Browns Ferry went online, TVA had planned and approved seventeen nuclear units with a projected total generating capacity of 21,573 megawatts, the largest nuclear-construction program in the country.[37]

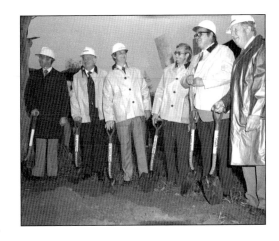

As TVA made strides with its nuclear program in the 1970s, the nation faced economic turmoil. Inflation spiraled upward. Energy costs skyrocketed due to an international oil embargo. The price of coal soared from five dollars a ton to thirty-three dollars a ton in ten years, then went up another ten dollars before stabilizing. Electric power rates rose across the nation, including the Tennessee Valley. Energy conservation became an unexpected priority, and TVA set in motion one of the nation's most ambitious home-weatherization and conservation programs. The average residential consumer was using more than sixteen thousand kilowatt-hours per year when the energy crunch hit. In response to rising rates and conservation efforts, consumer use dropped about 20 percent over the next few years.[38]

Before the decade ended, conservation, along with cutbacks in federal energy facilities, reduced the amount of electricity used, and TVA scaled back its massive nuclear-construction program by deferring the completion of four units. By 1982, five units—two at Sequoyah Nuclear Plant and three at Browns Ferry

The optimism of the Phipps Bend Nuclear Plant groundbreaking. October 25, 1977. (GR-77184)

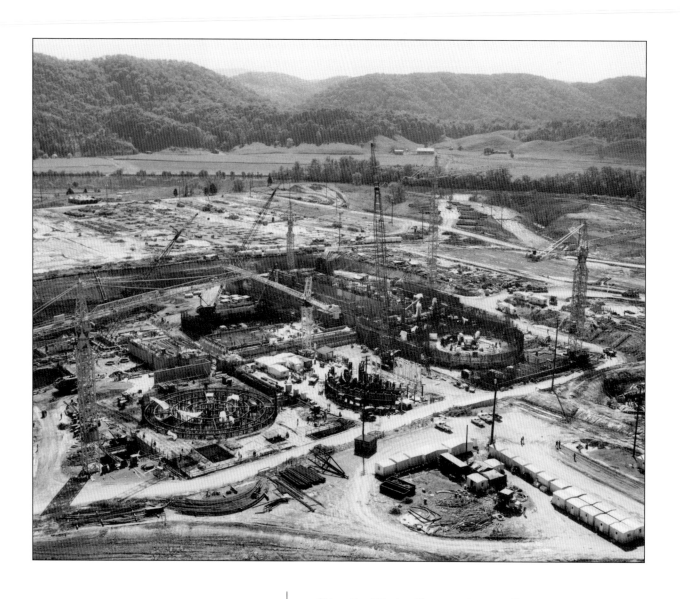

Phipps Bend Nuclear Plant, near Surgoinsville, Tennessee. TVA deferred construction and ultimately cancelled this plant in the early 1980s. October 15, 1979. (GR-79227)

Nuclear Plant—were in operation. Their combined generation in 1983 produced 26 percent of the total system production. TVA's nuclear-construction program outpaced the slowing demand for power, prompting TVA to cancel four units in 1982 and another four units in 1984, almost half those proposed between 1966 and 1974.[39]

TVA soon realized that nuclear power had its own share of environmental liabilities. In March 1979, the Three Mile Island nuclear accident, near Middleton, Pennsylvania, launched a new era of public scrutiny for commercial nuclear power and more intense regulatory control. Former TVA chairman John Waters explained that TVA did not respond well in this new era, especially to the increased regulatory control, which many nuclear managers viewed as an unnecessary intrusion. Management attention to the operating plants also was diverted by the large, ongoing construction program. As a result, TVA eventually found itself with a very troubled nuclear power system.[40]

A 1983 agency report on the state of the region's environment listed specific concerns with nuclear energy. This document noted that thermal discharges from a nuclear plant are much greater than those from a comparably sized coal-fired plant. Mining and milling of uranium create impacts on the surrounding land, water, and air. Nuclear plants also produce low-level radioactive wastes and spent reactor fuel, both of which require extreme care in handling, transportation, and disposal. And finally, disposal technologies and locations are extremely emotional, controversial issues.[41]

By August 1984, the Nuclear Regulatory Commission (NRC) increasingly applied pressure to TVA to improve its operating practices and bring the TVA nuclear facilities into compliance with the safety-oriented post–Three Mile Island regulations and design changes. The five licensed units at Browns Ferry and Sequoyah were behind schedule for many of the required modifications. Engineering design plans, calculations, and operation procedures were either deficient or, in some cases, nonexistent. The NRC questioned TVA's nuclear program in minute detail.[42]

Recognizing the environmental and the safety issues, and with energy demand dropping while construction costs rose, the agency scaled back its nuclear development program. While TVA began construction on seven nuclear plants, only three ever generated electricity. In 1985 TVA voluntarily shut down Browns Ferry

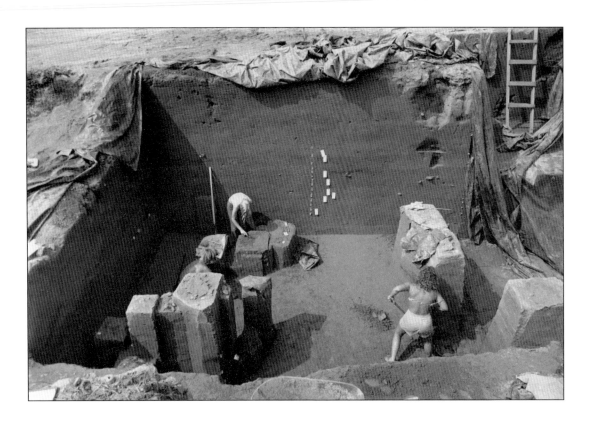

and Sequoyah to correct technical and management problems. At the same time, the Tennessee Valley suffered record drought conditions, and hydroelectric generation was about 44 percent below expectations. For three years, TVA's fossil and hydro group was credited with "keeping the lights on" and supplying the region with dependable power.[43]

Archaeological excavation, Tellico Reservoir. TVA began conducting archaeological investigations as early as 1934. Investigations continue in TVA project areas where the terrain will be altered by construction. Prior to the construction of Tellico Dam and Reservoir, TVA allowed the University of Tennessee to conduct archaeological investigations focused on the prehistoric and protohistoric occupation of the area—mainly the Cherokee. The historic Cherokee towns of Chota, Tanassee, Mialiquo, and Citico were studied and documented. These studies and others conducted through the 1980s identified almost five hundred archaeological sites along Tellico Reservoir lands. Circa 1976. (309)

Rivaling the agency's nuclear program in controversy was the construction of Tellico Dam. The location of Fort Loudoun Dam, above the junction of the Tennessee and Little Tennessee rivers, ultimately led to the construction of Tellico. Construction of the second dam had been discussed as early as 1936.[44] While it had been on the drawing board for years, TVA did not announce the project to the public until 1965, and, to the agency's surprise, the public balked.[45] The agency explained how Tellico would add to the water control system and would increase economic development in the Tennessee Valley, but many people did not agree that the benefits outweighed the loss of many farms. Furthermore, many archaeological sites were situated in the area where the reservoir was to be built, and the preservation of these sites had to be addressed.[46] TVA later reported "excavations at the Icehouse Bottoms site produced the earliest known human skeletal material from Tennessee and the earliest known use of textiles in the eastern United States."[47]

But while the Tellico project resulted in many controversies, the most contentious involved a small, seemingly innocuous fish—the snail darter. In 1973 David Etnier, zoologist and professor at the University of Tennessee, discovered the snail darter in the Little Tennessee River.[48] That same year, Congress passed the Endangered Species Act. One of the provisions of this legislation included Section 7, which stated that "all Federal agencies were required to undertake programs for the conservation of endangered and threatened species, and were prohibited from authorizing, funding, or carrying out any action that would jeopardize a listed species or destroy or modify its 'critical habitat.'"[49]

In 1975, the first listing of endangered species, which included the snail darter, was released. The Tellico Dam was about 75 percent complete at this time. When finished, the dam would impound almost the entire known habitat of the fish, leading to possible extinction. A suit seeking preliminary and permanent injunctions against further construction of Tellico Dam was filed against TVA. The case was ultimately heard by the Supreme Court. The Court upheld a lower court ruling against the beleaguered agency. Ultimately, it

Fisheries biologist Gary Hickman prepares to transplant the snail darter from the Little Tennessee River to the Hiwassee. Circa 1975. (2007-33)

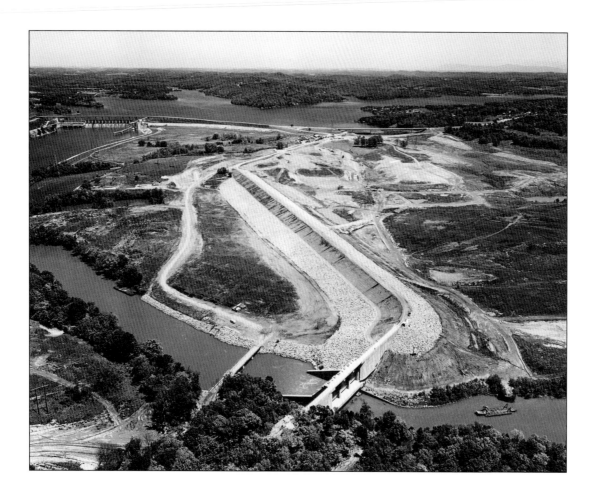

Tellico Dam with Fort Loudoun Dam in distance. One of the most controversial hydroelectric projects in TVA's history, Tellico Dam sits near the mouth of the Little Tennessee River in Loudon County, Tennessee. Construction began in 1967; however, issues regarding the snail darter, an endangered species, and Cherokee Indian sacred sites delayed the closing of the gates until 1979. The dam has no lock or powerhouse. Instead a short canal connecting Tellico Reservoir with nearby Fort Loudoun Reservoir provides river tows access from the main Tennessee River barge channel, and diverts the flow of the Little Tennessee through Fort Loudoun powerhouse for additional power. The two reservoirs are operated jointly for flood control, more than doubling the storage available at this key point in the TVA river control system. May 2, 1978. (GR-78038)

was Congress that passed legislation allowing the dam to be completed in 1979.[50] In the end, both TVA and the snail darter survived the Tellico project. During the late 1970s, TVA transplanted a population of 710 snail darters to the Hiwassee River, a tributary of the Tennessee River. By 1983, the initial population of the fish had expanded to 3,000. Other natural populations of the snail darter have since been discovered in other parts of the eastern valley.[51] Today the snail darter exists in Alabama and Georgia, as well as Tennessee.[52]

By the early 1980s, critics depicted TVA as an off-track and bloated bureaucratic government agency. Like most of America, the agency was struggling with the impact of an economic recession. In 1982, Americans experienced the worst financial downturn in this country since the 1930s. While inflation was less than 6 percent, national unemployment rates mushroomed to 11 percent by the end of 1982.[53] At this same time, unemployment rates in Tennessee mirrored the national percentage while many rural areas experienced levels of unemployment above 20 percent. For the first time in forty-nine years, electric needs in the Tennessee Valley failed to increase. Coal-fired generation struck a fifteen-year low, and power sales to TVA's large, industrial direct-served customers slumped to their lowest levels in two decades.[54]

By 1982, TVA confirmed that the outlook for electricity sales was very low compared to the projections made in the early 1970s.[55] To meet these projected energy demands, TVA had embarked on the largest nuclear construction program in the country.[56] In the process, the agency had incurred tremendous costs and amassed a massive debt. By the 1980s, these costs were reflected in rising power rates.[57] In an effort to get the agency back on course, the board of directors adopted a three-pronged plan: (1) reduce the need for more borrowing, (2) decrease employment by 20 percent, and (3) slow the growth of power costs and rates.[58]

Even with these changes, TVA continued to struggle throughout the 1980s. Editorials in valley newspapers reflected public opinion:

The TVA has been the target of criticism since it was conceived more than 50 years ago by a U.S. Senator from Nebraska. Most of the past criticism has come from Congressmen outside the TVA region. The situation has changed. TVA has become the object of sharp questioning from Congressmen and customers in the seven states served by the institution. . . . The subject under question is TVA's management, particularly its non-functioning

$14 billion nuclear program. TVA has been a boon for the seven states under its charter, but costly, potentially dangerous mismanagement cannot be tolerated.[59]

By the fall of 1987, TVA directors Charles H. "Chili" Dean, Jr., and John Waters wrote in the annual report to the president and Congress that "by making progress toward solving some of the most complex problems this agency has faced in recent years . . . TVA helped lay a stronger foundation for the region's growth." They went on to mention that they were "pleased to welcome Marvin Runyon to TVA as Chairman. We look forward to serving with him as TVA builds on its accomplishments as a national laboratory and pursues its goal of becoming a model of government quality, productivity, and innovation."[60]

The appointment of Marvin Runyon proved to be a watershed moment in TVA history. Given the charge of making TVA more competitive, the former Ford and Nissan executive wasted no time in bringing about change. Runyon, who earned the name "Carvin' Marvin" for his massive layoffs in 1988, worked to streamline the agency and adopt modern business management practices. With Runyon as chairman, TVA began its transition from a regional bureaucracy to a more competitive, more efficient, and more focused corporation.[61] For example, his 1991 letter to Congress regarding the state of the agency stands in stark contrast to other, earlier letters. Peppered with a business vocabulary, Runyon wrote:

In fiscal year 1991, TVA's employees worked hard to keep power rates constant, cut overhead expenses, and adopt more efficient and competitive business practices. We also strengthened the human and natural resources of the region through innovative and cost-efficient programs. Now with our total quality initiative underway, we are gaining a clearer focus on what it takes to meet our customers' needs. . . . We are dedicating ourselves to customer

TVA Board of Directors, 1988. Pictured from left to right are Charles H. "Chili" Dean, Jr., Marvin Runyon, and John Waters. (7758-19)

satisfaction and to constantly improving the efficiency and quality of everything we do for the people of the Tennessee Valley, the nation, and the world.[62]

While these changes were sometimes painful to TVA's employees, Runyon took measures that allowed the agency to survive.[63] When Runyon left the agency in 1992, he had reduced management layers, cut overhead costs by more than 30 percent, and achieved cumulative savings and efficiency improvements of $1.8 billion. He stabilized rates and changed TVA to the point that the *Wall Street Journal* reported that "the utility is regarded as one of the most effective of federal agencies."[64]

In the decade of the 1990s, TVA officials continued to stress the goals of competitiveness, customer focus, and innovation in all areas of its business as the agency, and the electric-utility business in general, moved

Sign advertising TVA's role in the 1996 Summer Olympic Games.

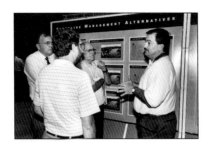

towards possible deregulation. TVA cut operating costs by nearly $800 million per year and reduced its workforce by half. It began a $100 million, long-term improvement effort to increase the efficiency of its hydroelectric facilities. The agency stopped building nuclear plants and developed a comprehensive plan, Energy Vision 2020, to meet the energy needs of the Tennessee Valley through the year 2020.[65]

TVA also continued its mission of promoting economic development in the Tennessee Valley. For example, in 1996, TVA supported the location of the Ocoee River in southeastern Tennessee as the venue for the 1996 Olympic white-water slalom events. That one event poured over $90 million into Polk County and created a white-water rafting industry that adds more than $30 million per year to the local economy. That same year, in recognition of emerging international markets, TVA cohosted a series of meetings in China between sixty-five regional business leaders and the Chinese government. Goals of the meetings were to open the doors for international trade, assist China in developing its energy resources, and help create new jobs and expanded opportunities in valley communities.[66]

Environmental issues remained a priority of the agency. To comply further with the Clean Air Act, TVA unveiled a new clean-air strategy to reduce the pollutants that cause ozone and smog. This new approach allowed TVA to install scrubbers at several of its fossil plants. By early 2005 TVA had met its commitment to reduce its ozone-season nitrogen oxides emissions by 70 to 75 percent below 1995 levels. It is also on track to meet its commitment to reduce sulfur dioxide emissions to 80 to 85 percent of 1977 levels by 2010. At that time, TVA will have spent $5.7 billion on clean-air modifications to its coal-fired plants.[67]

To address issues of water quality, TVA launched the Clean Water Initiative, a joint effort between TVA, other government agencies, private organizations, and individuals, to make the Tennessee River the cleanest,

Shoreline Management Initiative meeting, Clinton, Tennessee. From left are Bob Brooks, environmental compliance service project manager; lakefront-property owners Kenneth Turner and Paul Davis; and Hugh Standridge, TVA land-use specialist. TVA held a series of public meetings across the Tennessee Valley region to gain input about permitting residential-shoreline alterations. July 30, 1996. (11699-3)

most productive commercial river system in the United States. TVA, with much public involvement, also examined its system for granting permits for docks and other shoreline developments. The result was the adoption of the Shoreline Management Policy in 1999, a valley-wide initiative to improve the protection of eleven thousand miles of shoreline and aquatic resources while allowing reasonable access to the water.[68]

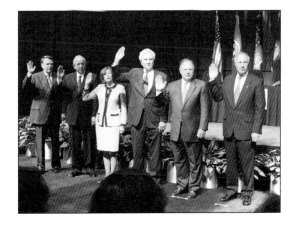

Along a similar line, in May 2004, the TVA board adopted a new policy for operating the Tennessee River and reservoir system. The agency conducted a comprehensive review of its dam and reservoir management policies, a process that included consultation with the public and other federal agencies. This reservoir operations study resulted in the development of an improved policy that accommodated increased recreational and residential uses while maintaining commitments to flood control, commercial navigation, power production, and water quality. Highlights included leaving reservoir levels higher through Labor Day and ensuring that areas prone to flooding will not have an increased flooding risk as a result of changes in operating policy.[69]

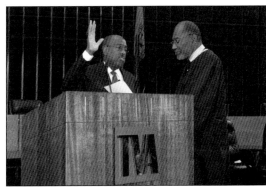

TVA has continued to downsize since 1988, but the agency remains competitive with fewer than thirteen thousand full-time employees.[70] Fiscal year 1999 was the last year that TVA received federal appropriations for its environmental stewardship and economic development activities. The agency now funds all activities, including river navigation and conservation programs, from

(*Top*) New part-time TVA board being sworn into office. From left to right are Mike Duncan, Howard Thrailkill, Susan Richardson Williams, Don DePriest, Dennis Bottorff, and Bill Sansom. Two other members of the board, Skila Harris and Bill Baxter, did not have to be sworn again as they were current directors. Bishop Graves had not been appointed at this time. March 31, 2006. (*Bottom*) Bishop William Graves sworn in as ninth board member. October 10, 2006. (DSC_0038)

the sale of electricity and power system financings.[71] As a result of these financial changes, TVA has identified essential operations. Some programs, such as the world-renowned fertilizer program at Muscle Shoals, Alabama, no longer exist. Those same facilities at Muscle Shoals are now focused on developing energy and environmental technologies to address challenges in the twenty-first century.

One of the most significant changes to the agency occurred as part of the Consolidated Appropriations Act of 2005. Congress enacted amendments to the TVA Act that mandated fundamental changes to TVA's governance structure—from a three-member, full-time board of directors to a nine-member, part-time board.[72] In its short tenure, this board has made some monumental decisions that will affect the agency and the region for many years. It appointed Tom Kilgore as the agency's first-ever president and chief executive officer; it approved a strategic plan for the agency's future direction; it adopted a controversial land policy, which allows no TVA public land to be used for residential development; and it approved the completion of Unit 2 at Watts Bar Nuclear Plant in Spring City, Tennessee. This board's decision to complete Unit 2 at Watts Bar, coupled with the restart of Unit 1 at the Browns Ferry Nuclear Plant in north Alabama in May 2007, positions TVA to lead the nuclear renaissance in the United States.[73]

After seventy-five years, TVA continues its mission to improve the quality of life in the Tennessee Valley through three key areas: energy, environment, and economic development. TVA continues to provide affordable, reliable electric power that helps businesses and families prosper; it helps the region thrive and enables residents to enjoy a higher quality of life by managing the Tennessee River and adjoining lands to provide a better environment for future generations; and it builds partnerships that foster economic prosperity. There is no question that TVA has played, and continues to play, an important role in the development of the Tennessee Valley. While much has changed in this region since 1933, remarkably, TVA is still here. In spite of its turbulent history, the agency remains a viable, innovative, and still controversial force in the region. Gordon Clapp, chairman from 1946 to 1954, once remarked that "TVA is controversial because it is consequential; let it become insignificant to the public interest, an agency of no particular account, and people will stop arguing about it." In its seventy-fifth year, TVA remains significant to the region and the people it serves.

TVA Photographers, 1963–Present

The Tennessee Valley Authority maintains a remarkable collection of photographs. Since the beginning of the TVA, the board of directors has hired skilled and talented individuals to document, through photography, the work of this unique agency. Fortunately this tradition continues. While the early agency photographs rival more famous work done by the Farm Security Administration, the most recent photographs still reflect the quality, innovation, and attention to detail found in earlier work.

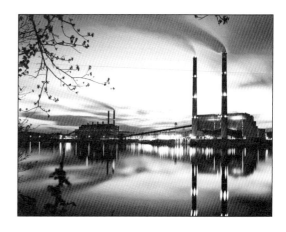

TVA had various units taking photographs. For example, engineering photographs document, in detail, the construction of each TVA power facility. These Construction Progress Negatives, housed at the National Archives and Record Administration's (NARA) Southeast Region, located in Morrow, Georgia, are quite technical in nature. They illustrate the construction process, step by detailed step. These photos do not just show a dam; they show specifically the "base of sealing pit" or "looking downstream from spillway."[74] Each month, an engineering photographer would capture the construction process from the same spot until the project was completed.

Housed at the same NARA facility is another set of images known vernacularly as the "Kodak" Negatives. Taken by field workers, as opposed to professional photographers, these images provide a record of the homes and businesses the agency acquired in order to build the dams and reservoirs. For historians and genealogists, these images are priceless.

(*Top*) Dramatic view of Widows Creek Steam Plant at night. N.d. (GR-89001) (*Bottom*) Shadows at the Dogwood Arts Festival Parade, Knoxville, Tennessee. Circa 1970s. (1029-10)

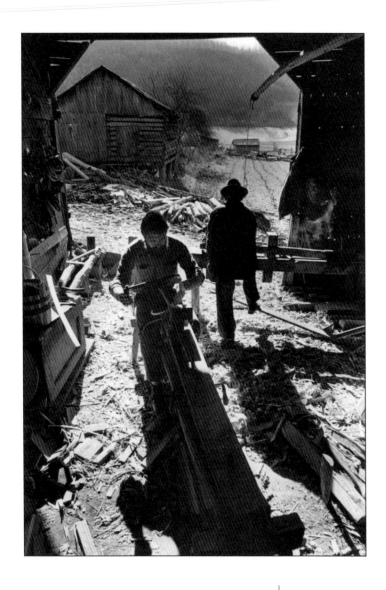

Workshop of famed cooper Alex Stewart, Hancock County, Tennessee. Circa 1976. (339-35)

All of these photographs differ from the images presented in this volume. Again, as in the first volume (*TVA Photography: Thirty Years of Life in the Tennessee Valley*), the images presented here are still maintained by TVA and were always destined for public relations purposes—many appeared in annual reports, in other agency publications, or, as is the case today, in the agency newspaper, *Inside TVA*. Most of the images were taken by professional photographers working in the agency's information or communications division.

One such photographer was Billy H. Glenn, who began his career at TVA by assisting engineers taking the construction engineering photographs. He soon joined the graphic arts staff in TVA's information office and worked under chief photographer Charles Krutch. The two of them produced many spectacular photographs of TVA's infancy and growth. When Krutch retired in 1954, Glenn succeeded him as the agency's chief photographer. Several images, most likely taken by Glenn, are reminiscent of earlier images. For example, the one of the worker in the tunnel at Browns Ferry Nuclear Plant is quite similar to one taken in the wicket gate at Norris Dam. Fittingly, Norris was the first hydro facility constructed by the agency and Browns Ferry the first nuclear plant. The image of workers leaving the Browns Ferry construction site harkens back to photographs taken of the many construction workers during World War II and in the postwar period. Glenn remained chief photographer for the rest of his career. He retired in 1972 after working thirty-nine years at the agency, leaving a legacy of quality work.[75]

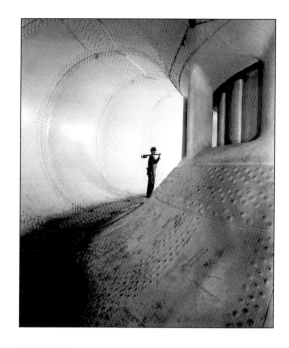

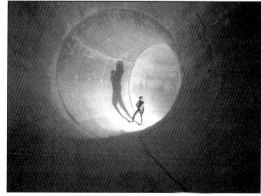

(*Top*) Wicket gate at Norris Dam. 1937. (K-1207AA) (*Bottom*) Construction worker in tunnel, Browns Ferry Nuclear Plant. Circa 1971. (KX-9770)

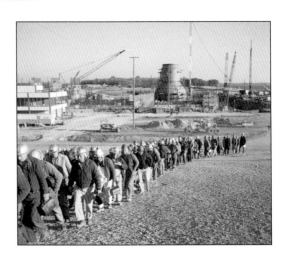

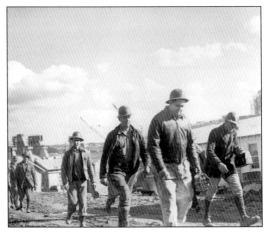

Shortly after Glenn retired, Robert Kollar joined the information office staff in 1976 to write and shoot photos as an associate editor of the magazine *Perspective* and the newspaper *TVA Today*. A graduate of Louisiana State University, Kollar worked for United Press International and two Tennessee newspapers, *The Commercial Appeal* in Memphis and *The Tennessean* in Nashville before coming to TVA. During his last four years with *The Tennessean*, he traveled through west and middle Tennessee, photographing and writing about the people and communities, which well prepared him for his work at TVA.[76]

In 1980 TVA initiated publication of the newspaper *Inside TVA*. As demand for photographs for the paper increased, Kollar spent more time taking pictures than writing.[77] As his career progressed, he was eventually named chief photographer for the agency. When asked what he enjoyed most about his job, Kollar responded that it was "the opportunity to meet so many employees in so many different locations all across TVA and see what they do. It's fascinating how all the different pieces fit together."[78]

Over the scope of his career, Kollar has probably been to more TVA facilities and met more employees than any staff photographer in the last thirty years. His job as photographer has put him on trains, boats, and planes, in helicopters and on coal barges. He has climbed up a 500-kV transmission tower and down into a uranium mine. He has been in the tunnels below the dams and, during outages, in the boilers of the fossil plants. In fact, Kollar has documented much of TVA's recent history through his images. He cites two shoots as

(*Top*) Construction workers at lunch break, Browns Ferry Nuclear Plant. November 6, 1968. (KX-8578)
(*Bottom*) Construction workers, Douglas Dam. February 7, 1943. (KX-1975)

highlights of his career: "I photographed former Chairman David Lilienthal's return visit to TVA in 1979 and the visit of President Jimmy Carter in 1978," he says. "And it was exciting to cover TVA's participation in the World's Fair in 1982 and the 50th-anniversary celebration the following year."[79]

Kollar has chronicled photographically all or part of the TVA careers of eleven of the agency's directors, beginning with Red Wagner. He has endured weather conditions and natural hardships to get the shot; one assignment, for example, took him to an island on Guntersville Reservoir where herons were nesting. "I was shooting photos, and suddenly I started hearing these 'splats' all around me," he says. "I looked up and saw the herons dropping dead fish. The biologist with me said that was the way herons drive intruders away from their nests. Fortunately, I got some nice pictures and never did take a direct hit."[80]

When asked about his favorite photograph, he mentions two: one, an ironworker having lunch at Bellefonte; and two, a set of transmission lines in Jefferson County, Tennessee, glowing in the late afternoon sun. He has been the recipient of numerous awards. In 1987, he was one of ten employees to win a TVA Gold Honor Award symbolizing the best of the best. His international honors include an APEX Grand Award as well as one of the International Association of Business Communicators Gold Quill Awards. The assignment he enjoyed most for TVA was taking photographs for the book *The Tennessee Valley: A Photographic Portrait*. His color photographs ap-

(*Top*) David E. Lilienthal revisits the Tennessee Valley. 1979. (10077-31) (*Bottom*) TVA exhibit, Knoxville World's Fair. June 1982.

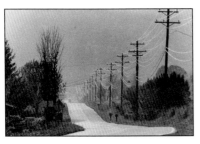

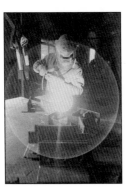

pear in this work with text written by Kelly Leiter, dean emeritus of the University of Tennessee's College of Communication.[81] Kollar retired in 2002.

Filling the role of the agency's chief photographer today is Cletus Mitchell. As manager of teleproduction and photography, he oversees the agency's photographic and video needs. He began his career at TVA in 1987 in Chattanooga taking photographs of the nuclear plants for the magazine *Upfront*. A reorganization in 1988 moved him to Knoxville as part of the communications staff. With this move, Mitchell began contributing to *Inside TVA*, and when Bill Lee, TVA's manager of video services, retired in the mid-1990s, Mitchell inherited Lee's film and video duties.[82]

Like Kollar, Mitchell knows this valley. He has visited every nuclear, fossil-fueled, and hydro plant. He shares two stories from his many adventures. The first story reflects the time involved in getting a shot. Nuclear called Mitchell around 11:00 p.m. Sequoyah was being refueled for the first time after the restart in the 1980s, and if he wanted the shots, he needed to get out there. Once there, he had to don the protective clothing to go into the nuclear unit and he had to wrap his camera in plastic. They were just getting ready to lift the head of the reactor off when the airborne alarms signaled a radiation alert. Everyone had to file out of the reactor chamber, which meant that Mitchell had to discard the protective clothing, unwrap his cameras, and be checked for radiation contamination. With the radiation contamination check complete, he had to don the protective garb again, rewrap his cameras in plastic, and wear a respirator. Back inside the nuclear unit, he prepared to take the photos when a sump pump began to leak. Everything stopped again for two hours. After hours of waiting, he finally got the shot of the refueling.[83]

(*Top*) Lunch break at Bellefonte Nuclear Plant. 1980s. (523-32A) (*Middle*) Transmission lines, Jefferson County, Tennessee. 1989. (5599-29) (*Bottom*) Welder working at Bellefonte Nuclear Plant. 1979. (523-17A)

Another story reflects the hazards of being a TVA photographer. In 1993 Mitchell was working on a week-long video shoot for a history film about the agency. This shoot took him to all of TVA's power plants, and on this particular day, he was in a helicopter over Kingston Fossil Plant with pilot Marlin Johnson. They had outfitted the helicopter with a camera on a gyroscope on one side and a weight on the other. Mitchell wanted a bird's-eye view, so the plan was to fly over the twelve-hundred-foot-high stacks and circle around. They were about fourteen hundred feet high as they went over the stacks, and the heat and smoke from the stacks sucked all of the oxygen out of the air. As Mitchell put it, "We had a flame-out—the engines quit, but the rotors were still turning. It was quiet except for the swish of the blades." Their plan was to autorotate, circle down slowly, and land in the coal pile, because the transmission lines were right below them and Melton Hill Reservoir was right beyond that. The helicopter lost altitude, but it was not out of control. They fell from fourteen hundred feet to around seven hundred feet before the helicopter's engine reignited. Mitchell related that he and the pilot agreed that they had "got enough stacks for the day."[84]

Like the other chief photographers before him, Mitchell has won numerous Gold Quill and APEX Grand awards for video and multimedia. He is most proud of the New York Film Festival awards in which he took honors every year between 1992 and 1996. Not only has Mitchell worked with traditional and digital cameras, but he has also branched out into high-definition video to record such historic moments as President George W. Bush's visit to Browns Ferry Nuclear Plant.[85]

While the individuals mentioned previously directed TVA's photographic efforts, there were many other photographers working at the agency during the last forty years. Dan Yearout, Olden Smith, Otis Crawford, Paul Moore, and Raymond "Steve" Corum are but a few of the employees whose jobs have included taking photographs.[86] Historically the file negatives and prints do not indicate the photographer. This practice

(*Top*) Boiler at TVA Fossil Plant. Circa 1990. (5617-10) (*Bottom*) Deer at LBL National Recreation Area. Circa 1980. (3400-11)

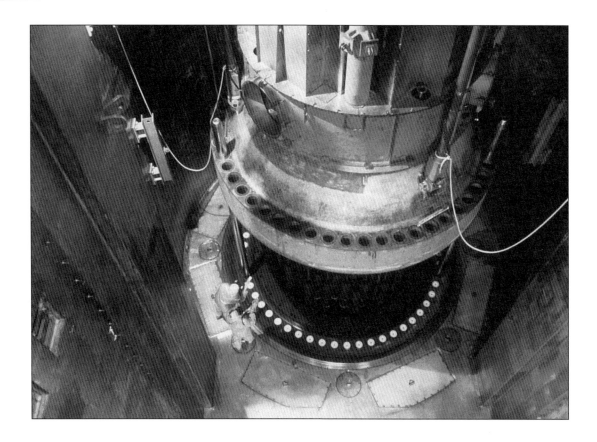

changed in the late 1970s and early 1980s when agency photographers began to label their images. Publications such as *Inside TVA* identify the photographers, and most images today can be attributed to individual photographers.

Besides the changes with identification, the technology of photography has changed. TVA's first photographers used large-format 8 x 10 and 5 x 7 cameras that were heavy and sometimes cumbersome to drag around

Sequoyah Nuclear Plant refueling. 1989.

the valley. These models gave way to the 4 x 5 and the 35mm camera. And amazingly, today, a cell phone can record an image. This digital image, a creation of computer technology, is rapidly becoming part of American life. It has certainly been a part of TVA's daily life for the past six years, as photographers use high-quality, digital cameras to record the images that document the agency's recent history.

In October 2006, shortly after TVA's board appointed Tom Kilgore as the agency's president and chief executive officer, he stated in a note that "TVA has a legacy unlike any other organization. When TVA began, it was synonymous with progress, opportunity and hope." He went on to say that times change and TVA's role is different, but that TVA's name today should be synonymous with efficiency, sustained value, creativity, and innovation.[87] As these photographs illustrate, times do change, but there is no doubt that the work TVA has done, and continues to do, reflects the characteristics listed above. TVA transformed the Tennessee River Valley and changed countless lives, and its work is not yet finished.

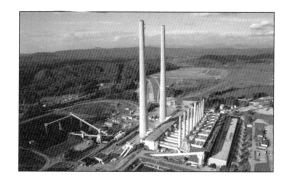

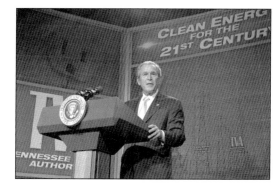

(*Top*) Kingston Fossil Plant, Kingston, Tennessee. Circa 1990s. (*Middle*) President George W. Bush addresses Browns Ferry Nuclear Plant employees during a visit to the plant on June 21, 2007. The president commended TVA for bringing the first nuclear reactor online in the United States in more than a decade. (DSC_0356) (*Bottom*) Silhouette of lineman. Circa 2000.

New Challenges, 1963–1978

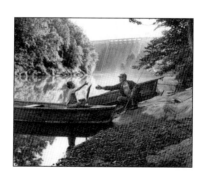

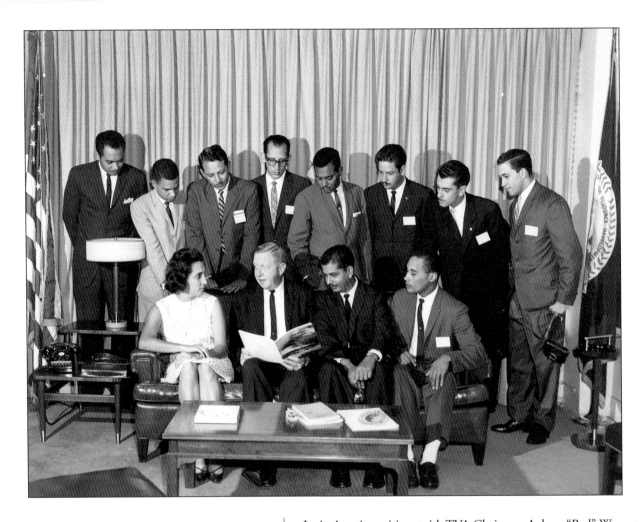

New Challenges,
1963–1978

Latin American visitors with TVA Chairman Aubrey "Red" Wagner. Between July 1, 1963, and June 30, 1964, more than twenty-four hundred persons from 107 countries visited TVA's Knoxville, Tennessee, headquarters to study unified resource development. Oftentimes these visitors participated in TVA's Resources Development Seminar, a program consisting of several weeks of discussions with high-level TVA personnel coupled with field trips in the Knoxville area and a ten-day trip throughout the Tennessee Valley. August 14, 1963. (KX-5680)

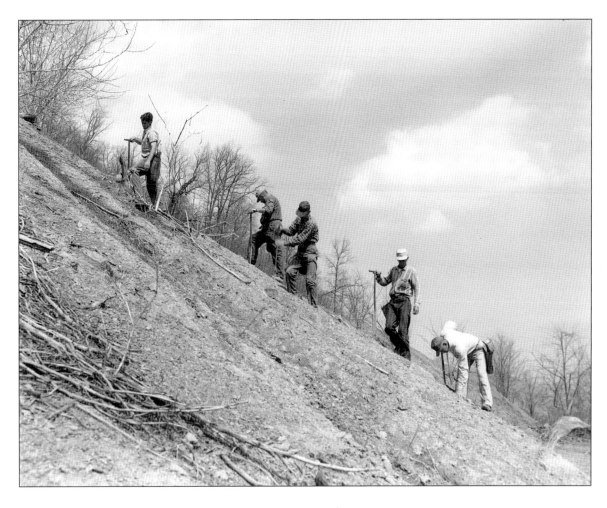

Accelerated Public Works (APW) Strip Mine Demonstration Project, Claiborne County, Tennessee. In 1964 TVA conducted public inspection tours to four reclamation demonstrations which it had established in east Tennessee and southwest Virginia. During the course of these demonstrations, about 160 landowners, coal operators, newsmen, and others saw the results of efforts to eliminate erosion problems, reduce stream pollution, and revegetate the stripped land for forestry and wildlife production. March 1, 1964. (KX-5776)

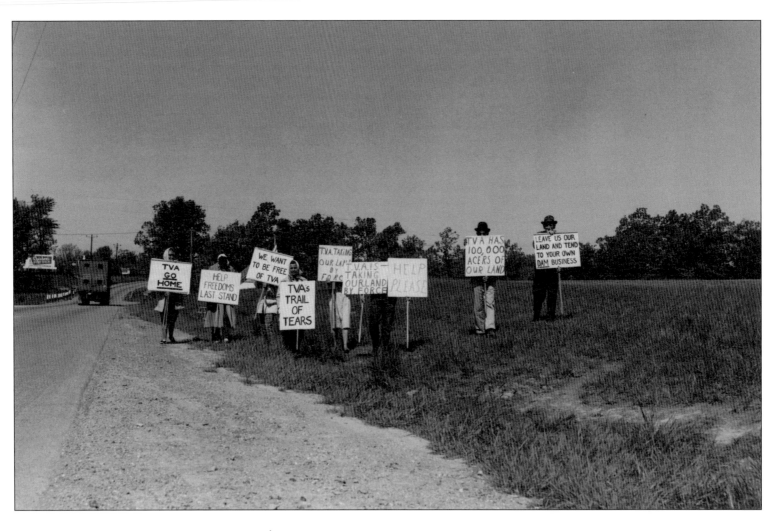

Protesters in front of the LBL Land Office, Golden Pond, Kentucky. TVA moved about nine hundred families from communities in the western part of the Tennessee Valley. The idea was not popular among many whose families had lived in the "land between the rivers" for generations. Community groups formed to express either support or opposition, as shown above, to the plans. April 30, 1964. (KX-5823)

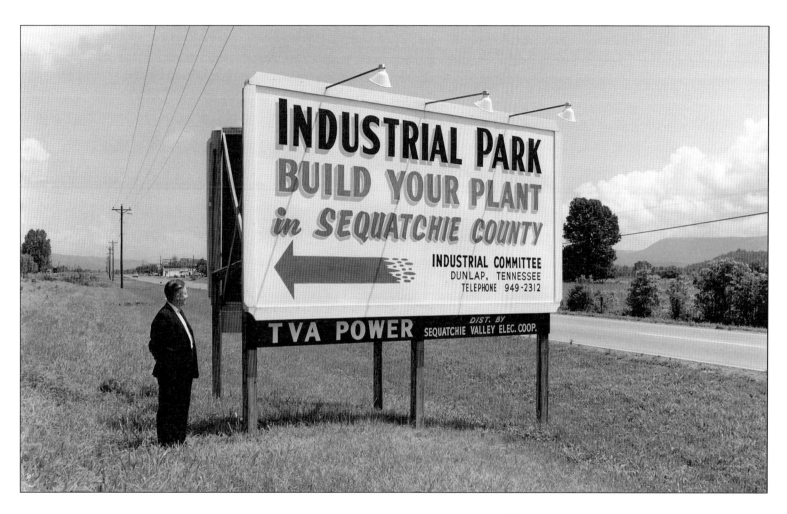

Briggs H. Smith with sign advertising Sequatchie County Industry, Dunlap, Tennessee, Industrial Park. Between July 1, 1964, and June 30, 1965, 194 new industrial plants located in the Tennessee Valley and 306 existing regional facilities expanded, partly as a result of TVA's lower electric rates. This increase in industrial development represented private investments totaling $380 million and provided thirty-two thousand new jobs in the valley. July 30, 1964. (KX-5935)

Wilmer Locke Farm, Tishomingo County, Mississippi. TVA's fertilizer program assisted American agriculture by developing improved and lower-cost fertilizers. This six-hundred-acre test-demonstration farm stands as an example of the benefits of fertilizer use: in 1964 the Tishomingo County corn yield decreased from thirty-nine to thirty-four bushels per acre while test-demonstration farms in the county increased their yields from fifty-five to ninety-three bushels. July 16, 1964. (KX-5920)

Bull Run Steam Plant construction. Located on Melton Hill Reservoir in east Tennessee, this plant has a single generating unit of nine hundred thousand kilowatts, one of the largest capacities in the country when construction was completed in 1967. September 16, 1964. (KX-5953)

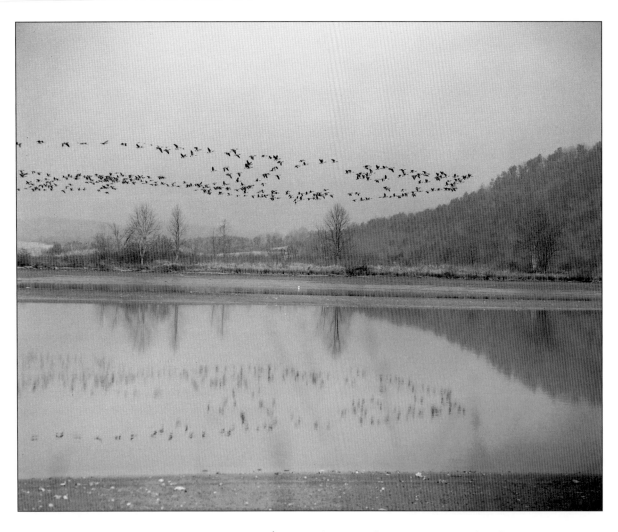

Canadian geese flying near Paint Rock Refuge, Watts Bar Reservoir. The Tennessee Valley did not attract many migratory ducks and geese until TVA impounded the reservoirs and worked in partnership with federal and state agencies to create wildlife areas, such as Paint Rock Refuge, throughout the Tennessee Valley. By the 1970s, more than three hundred thousand ducks and geese were wintering in the Tennessee Valley. January 22, 1965. (KX-6075)

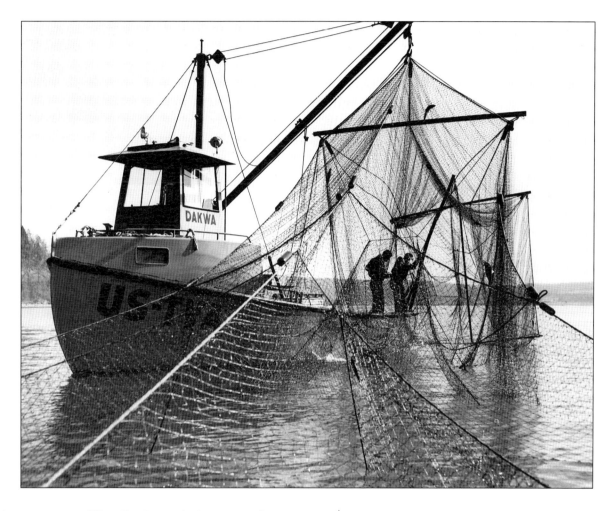

TVA Fisheries Research Unit raises a trap net on Watts Bar Reservoir. As a means of increasing the harvest of commercial fish and thus helping to improve the sports fishery, TVA experimented with two types of gear not used in the valley—the Great Lakes trap net, shown here, and the otter trawl. Trials indicated that the net may be useful under certain conditions. Catches averaged from 100 to 125 pounds per hour, but a profitable operation needs ten times that volume. December 8, 1965. (KX-6583)

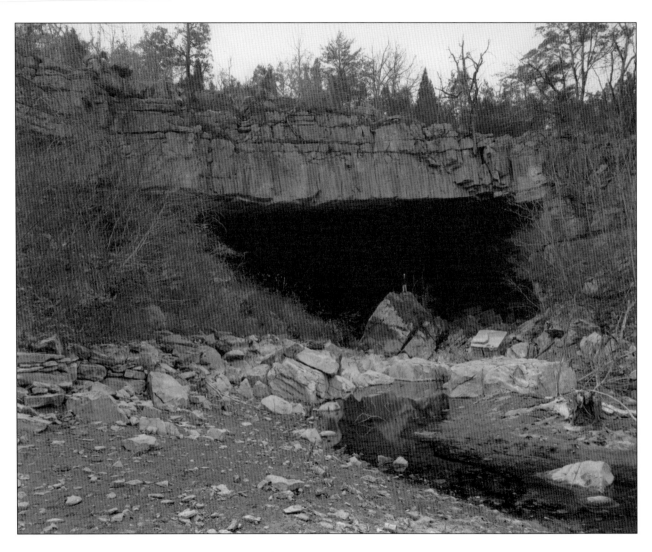

Nickajack Cave entrance. A Tennessee historical landmark located in Marion County, this cave was used by the Confederacy during the Civil War as a source of saltpeter. The impounding of Nickajack Reservoir partially flooded the entrance to the cave. In fact, the gentleman in the photograph would be covered by water today. November 18, 1965. (KX-6615)

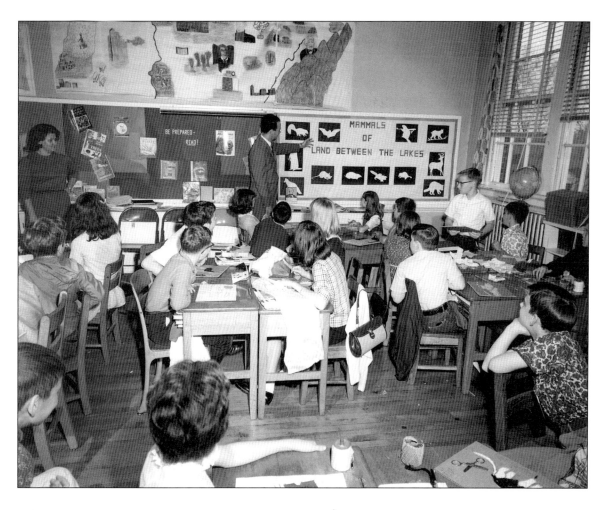

Members of Mr. Barnes's class at Middle Tennessee State University's campus school learn about mammals in anticipation of a trip to Land Between the Lakes. The youth activities station at LBL was put to use almost immediately after construction by the school group pictured above. Using a network of trails through the area, students visited sites demonstrating sound conservation practices, studied various biological sciences in the outdoors, and viewed historic structures. April 1, 1966. (KX-6750)

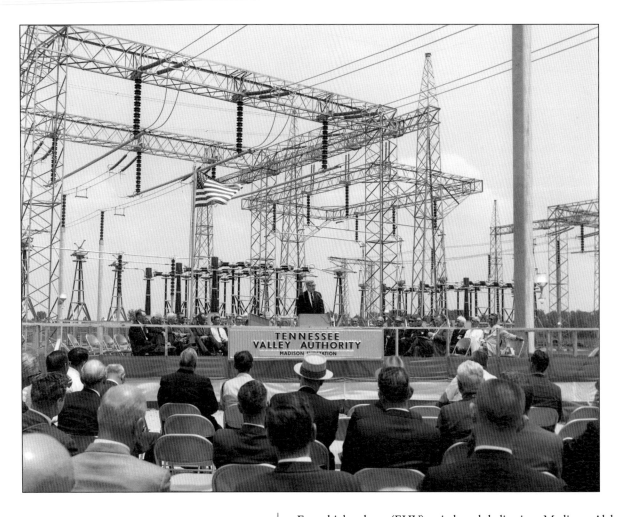

Extra-high voltage (EHV) switchyard dedication, Madison, Alabama. This EHV transmission line, TVA's second to be placed in service, extended 250 miles from Widows Creek Steam Plant in northeast Alabama to French Camp in Mississippi. This five-hundred-kilovolt line, along with large substations at Huntsville, Alabama, and West Point, Mississippi, greatly increased the power supply in these two states where loads were growing rapidly. May 25, 1966. (KX-6830)

New Challenges,
1963–1978

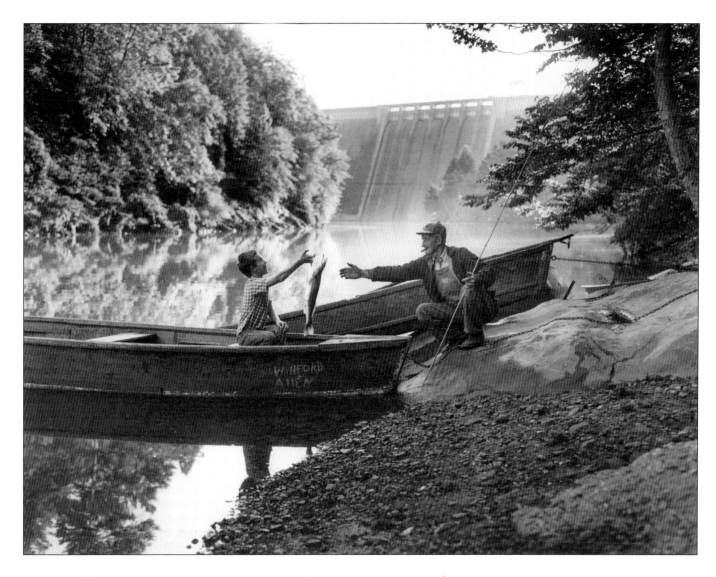

Fishing on the upper end of Apalachia Reservoir in North Carolina with Hiwassee Dam in background. TVA reservoirs attract fishermen, both young and old, in this idyllic scene. June 1966. (KX-7005)

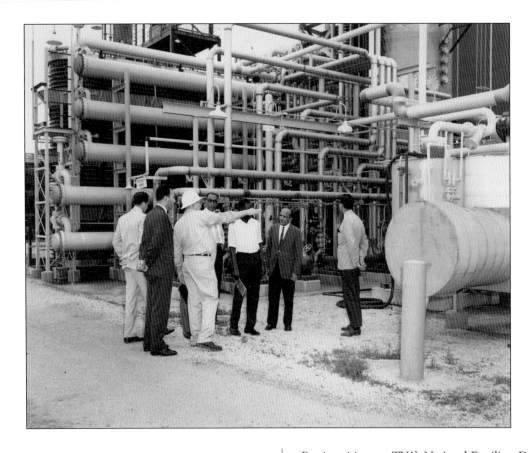

Foreign visitors to TVA's National Fertilizer Development Center (NFDC), Muscle Shoals, Alabama. TVA's fertilizer and agricultural research and demonstration programs attracted the interest and study of foreign countries seeking answers to their agricultural needs. The NFDC was one of the only institutions in the world which focused on agricultural problems by utilizing chemical research and engineering, economics of fertilizer manufacturing and marketing, and the agronomy associated with fertilizer use on varied soils and crops. TVA not only hosted foreign visitors, but also, at the request of the Agency for International Development (AID), sent teams of fertilizer specialists to Afghanistan, India, Morocco, Pakistan, Peru, South Vietnam, Turkey, Uruguay, and Venezuela. July 1966. (KX-7059-A)

Hales Bar Dam demolition crews. Hales Bar Dam, completed in 1913 by the Tennessee Electric Power Company (TEPCO), had the distinction of being the first multipurpose dam built on the Tennessee River. Increasing leakage through the limestone foundation, along with the prospect of providing new navigation facilities, led to the decision that a new dam, Nickajack, should be built. November 11, 1967. (KX-7873)

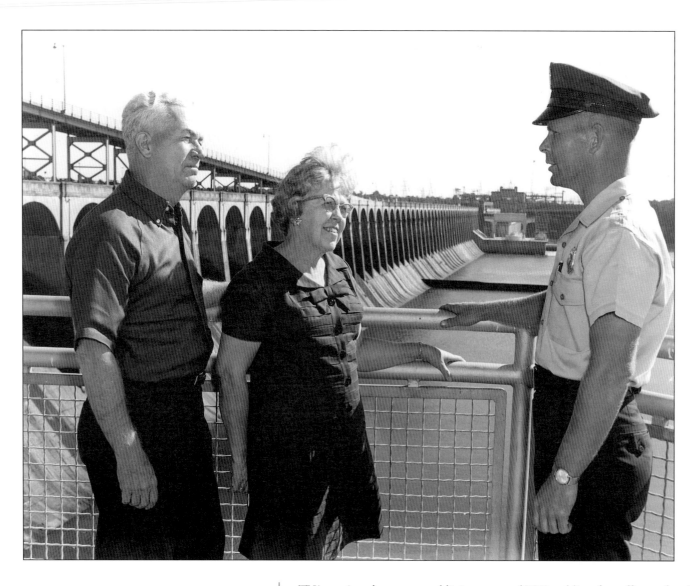

TVA continued to attract public interest, and TVA public safety officers often led tours of the various facilities. Here a TVA public safety officer at Wilson Dam in Muscle Shoals, Alabama, provides information to the two hundred millionth visitor to TVA. October 1, 1967. (KX-7882)

Farm in the Sequatchie Valley. While the Tennessee Valley moved toward industrialization, there were still glimpses of a more rural, agrarian lifestyle. October 1967. (KX-7896)

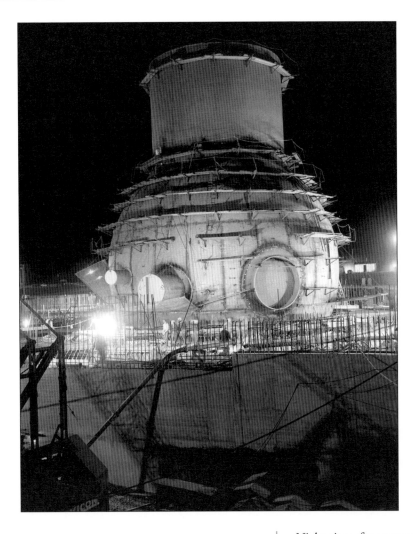

Night view of reactor containment vessel construction, Browns Ferry Nuclear Plant. At the time this photograph was taken, TVA had under construction or scheduled more new generating capacity than at any other time in its history. Browns Ferry, TVA's first nuclear plant, is located on the Wheeler Reservoir in north Alabama. Work began on this project in 1967, and it went into service in 1974. April 1, 1968. (KX-8103)

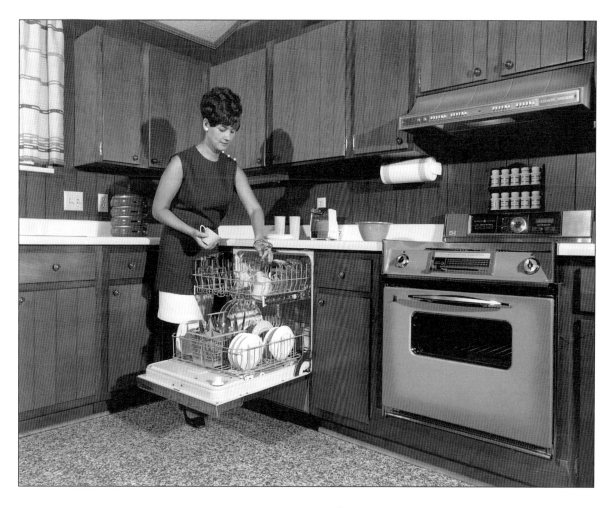

Knoxville Utility Board (KUB) home economist in model kitchen exhibit. Whether the appliances were harvest gold or avocado green, this all-electric kitchen with the built-in dishwasher was the dream of many women throughout the Tennessee Valley. The cooperative and municipal systems such as KUB, which distribute TVA-generated electricity, sold more than 41.8 billion kilowatt-hours to 1,990,400 residential, commercial and industrial, and other customers in 1968. July 3, 1968. (KX-8259)

Reservoir cleanup from toxic chemical spill, Boone Reservoir. Two large fish kills occurred on Boone Reservoir in upper east Tennessee in the late 1960s. The cause of the kills was eventually traced to a mercury compound leaking from a discarded metal drum found along the lakeshore. This reservoir was littered with hundreds of derelict drums used to float docks and boathouses and set free after they began to deteriorate. As a direct result of these fish kills, TVA announced that metal drums could not be used for flotation on any new floating structures on TVA reservoirs and set a deadline of 1972 for replacing drums already in use with more suitable types of flotation. February 25, 1969. (KX-8755)

Congressional tour of TVA. The House Flood Control Subcommittee, headed by Representative Bob Jones of Alabama, traveled by boat, automobile, and airplane to inspect TVA facilities from Florence, Alabama, to Knoxville, Tennessee. The four Republicans and nine Democrats making the tour were impressed with the work TVA was doing to improve the quality of life in the Tennessee Valley. In fact, one representative considered TVA the "finest example of water resource development in the world." October 1969. (KX-9097)

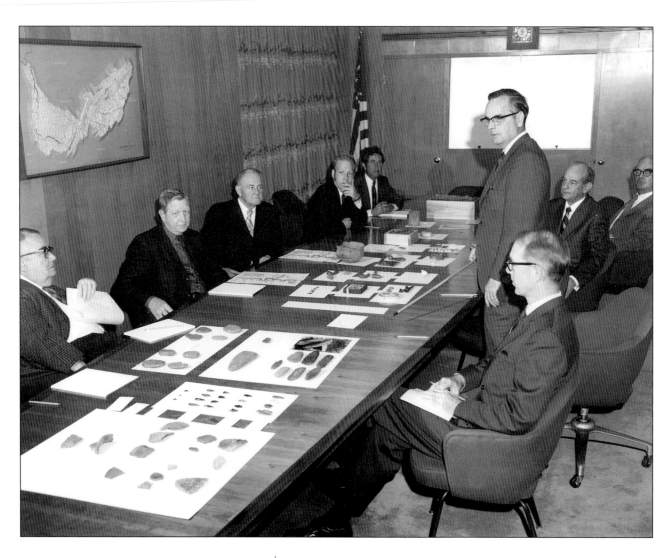

Dr. Alfred Guthe, chair of the Department of Anthropology at the University of Tennessee, exhibits Indian artifacts from Tellico for the TVA board. Prior to the construction of Tellico Dam, the University of Tennessee conducted extensive archaeological investigations of this area. April 3, 1970. (KX-9203)

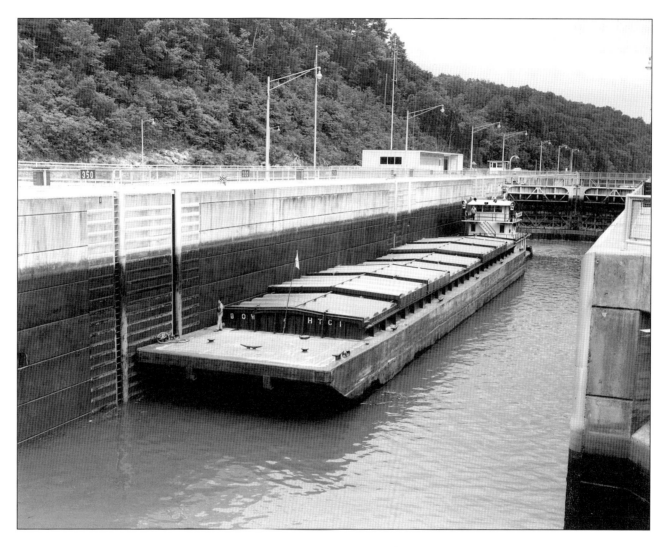

Allied Steel tow in Melton Hill Lock. Commercial freight traffic on the Tennessee River waterway totaled over 24.5 million tons in 1969, a record high for the eighth consecutive year. A new record was set in the total tonnage of iron and steel, seen in the image above, transported on the Tennessee River—over 806,000 tons. June 4, 1970. (KX-9336)

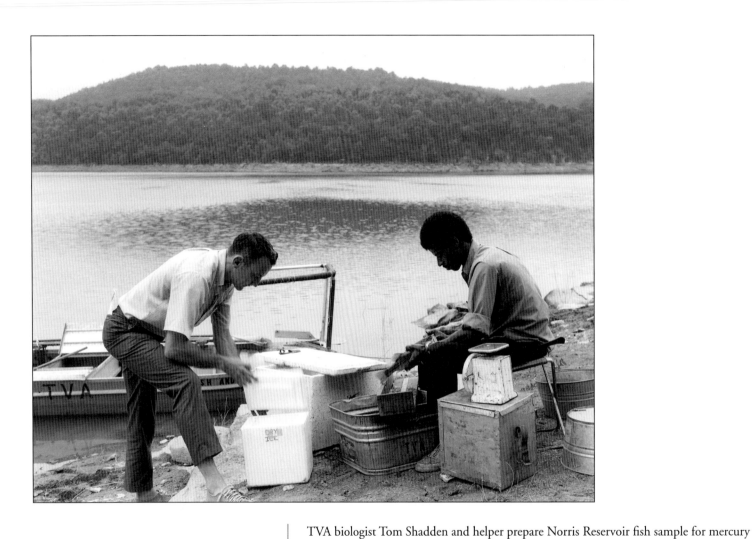

TVA biologist Tom Shadden and helper prepare Norris Reservoir fish sample for mercury test. The discovery of mercury pollution in TVA reservoirs led to a ban on commercial fishing in Pickwick Reservoir and a continuing surveillance of all reservoirs in the TVA system for mercury contamination. TVA obtained a complete profile of the mercury conditions in TVA reservoirs and partnered with state and federal agencies to control this pollution threat. July 21, 1970. (KX-9463)

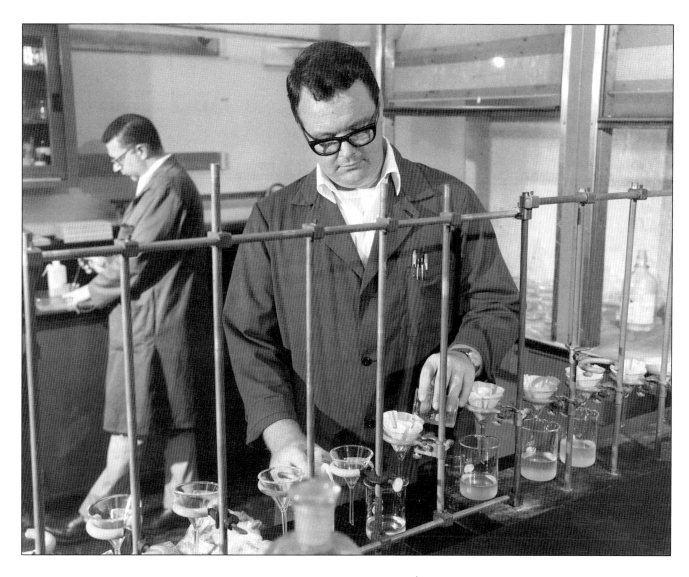

Filtering acid-digested water samples, water quality lab testing, Chattanooga, Tennessee. Runoff samples from watersheds across the valley help TVA scientists pinpoint conditions under which use of fertilizers may adversely affect water quality. August 30, 1970. (KX-9466)

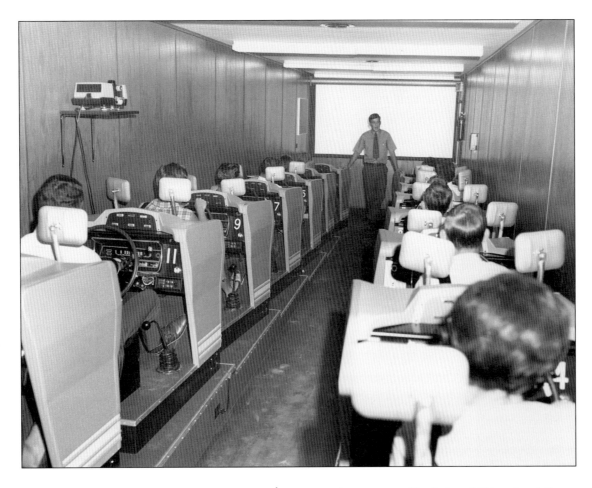

New Challenges,
1963–1978

Driver education van, Clinch-Powell Educational Cooperative. As part of its tributary area development initiative, TVA partnered with state and local educators and other interested agencies to organize and develop systems to serve specific educational needs. The Clinch-Powell Educational Cooperative, which included the Tennessee counties of Claiborne, Campbell, Hancock, and Union, worked together to improve the quality of education in their area by sharing facilities and teachers, as shown above, to permit students to take full advantage of the best curricula in each county's school system. August 18, 1970. (KX-9659)

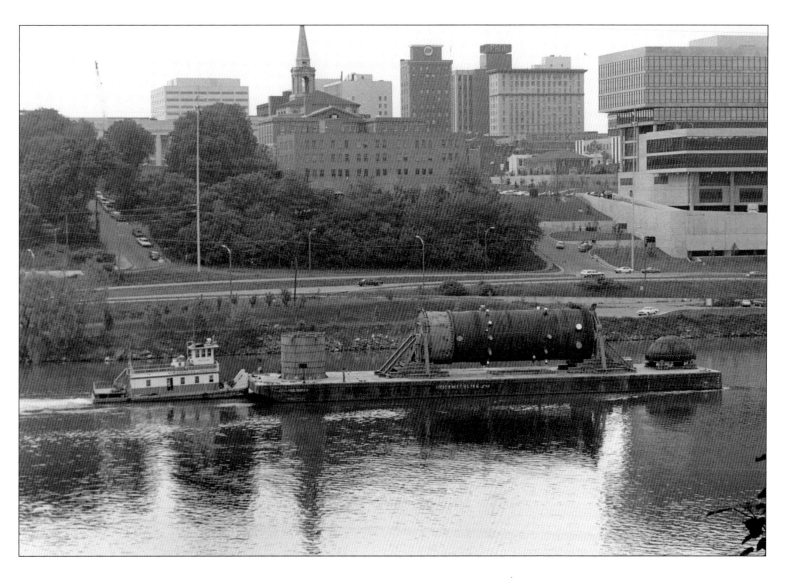

Barge on the Tennessee River at Knoxville, Tennessee, transporting 620-ton pressure vessel for Browns Ferry Nuclear Plant unit. Workers rolled the vessel to the site on trucks before it was lifted into the dry well. September 8, 1970. (KX-9708)

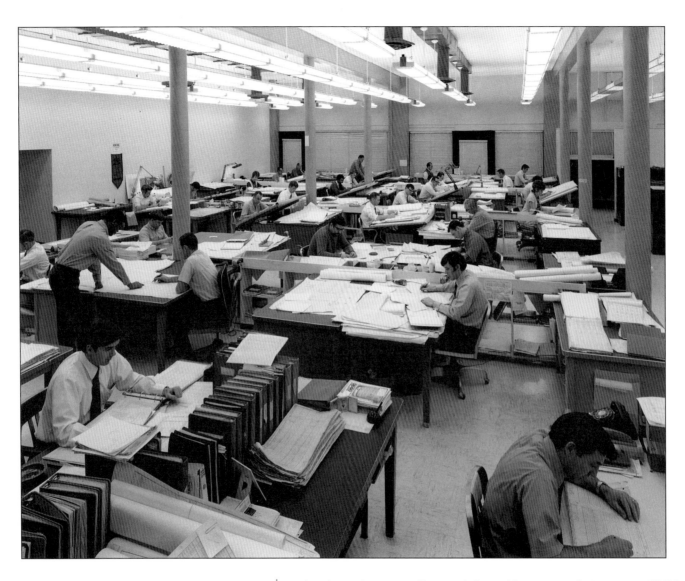

**New Challenges,
1963–1978**

The Electrical Design Office, Daylight Building, Knoxville, Tennessee. TVA had 25,829 employees at the end of fiscal year 1971, up 3,585 over the previous year, as the agency continued the largest power construction program in its history. February 1, 1971. (KX-9807)

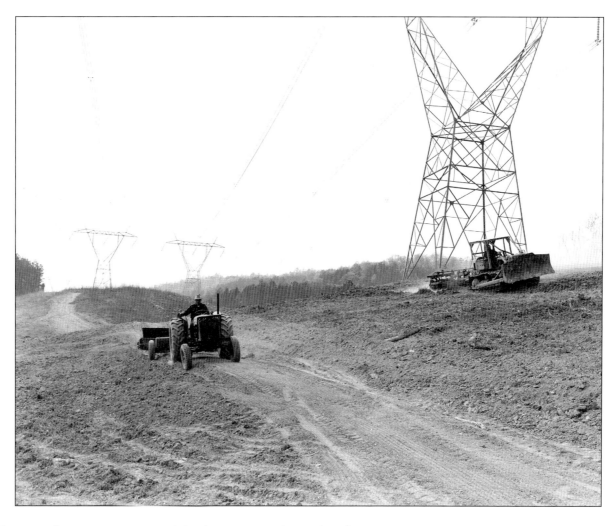

Preparing soil (right) and seeding grass demonstration near 500-kilovolt transmission line, Oak Ridge, Tennessee. In fiscal year 1971, TVA spent $433.3 million in construction expenditures, $122 million more than in 1970. Three-fourths of the cost represented generating plants construction, with the remaining cost covering transmission facilities. Those costs include seeding grass as shown above. April 20, 1971. (KX-9926)

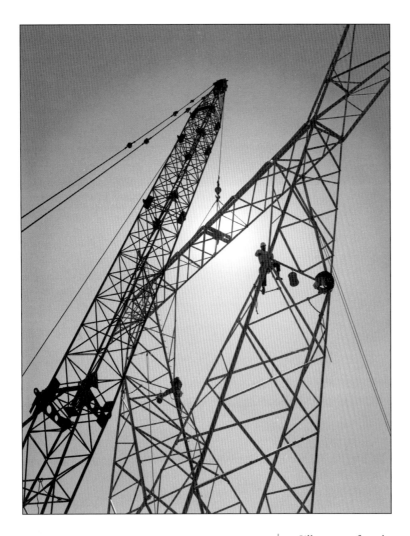

New Challenges,
1963–1978

Silhouette of workers on EHV transmission line, Sullivan County, Tennessee. TVA created
an extensive network of extra-high voltage (500-kilovolt) transmission lines and substations
throughout the Tennessee Valley. This particular line, running 124 miles to Bull Run Steam
Plant near Oak Ridge, Tennessee, interconnected with the American Electric Power Company.
October 28, 1969. (KX-10056)

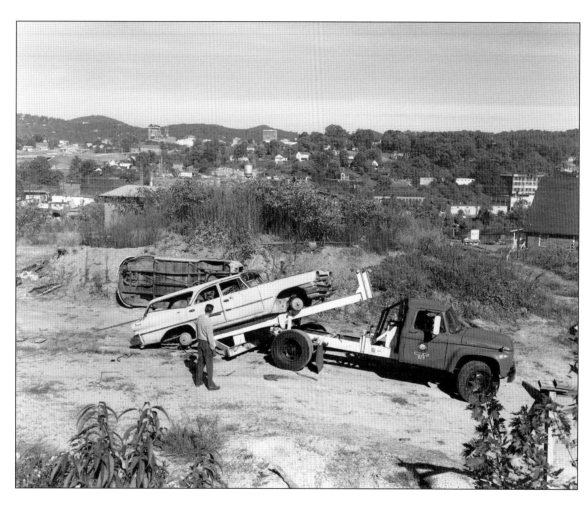

Junk cars being removed, Asheville, North Carolina. TVA, working to provide a clean and safe environment, partnered with local communities to collect and dispose of junk cars and solid waste. Communities in Tennessee, Virginia, and North Carolina collected over two thousand abandoned cars and sent them to be recycled through TVA's assisted cleanup program. More than 150 inquiries concerning this program came from organizations in thirty-four states. October 8, 1971. (KX-10300)

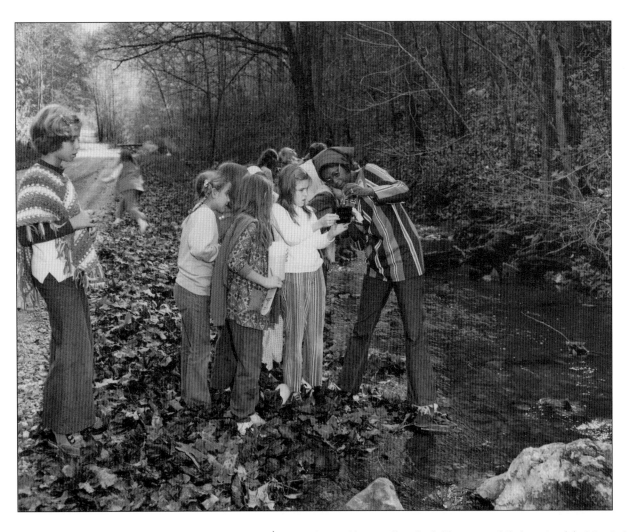

TVA's Geraldine Hall with children at mobile learning lab, Norris, Tennessee. As part of TVA's Environmental Education Program, TVA outfitted a panel truck with scientific equipment that could be moved from school to school. On this day in the field, the children learned about nature's recycling processes, soil erosion problems, water and air quality, and forestry. November 3, 1972. (KX-10543)

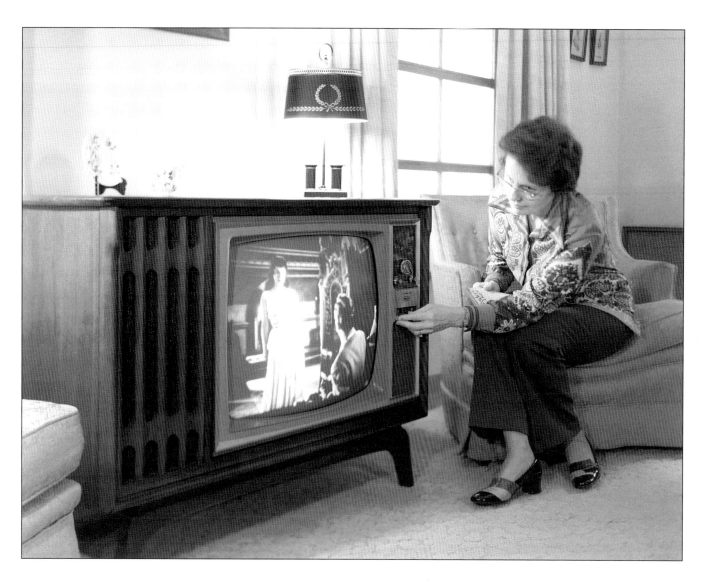

Mrs. Paul Moore watches television, Knoxville, Tennessee. TVs were a common electrical appliance in American homes by the mid-1950s, replacing the radio as a means of evening entertainment. November 16, 1972. (KX-10551)

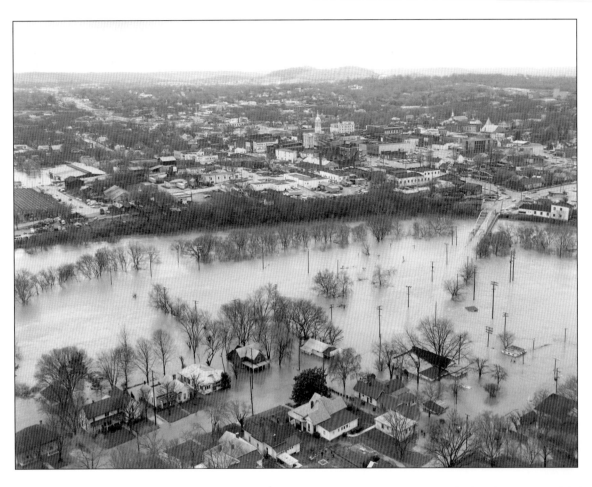

Flooding of the Duck River into the low-lying town of Columbia, Tennessee. This particular March flood came suddenly with unusual intensity. The heaviest rain poured down during the nights of March 15 and 16. Many rainfall stations reported 2 to 4 inches in six hours. Storm totals of 8 to 10 inches were common; the valley average was 6.1 inches. To prevent future floods from overflowing the banks of the Duck River, a tributary of the Tennessee, TVA planned two dams upstream on the Duck: Normandy and Columbia. March 17, 1973. (KX-10627)

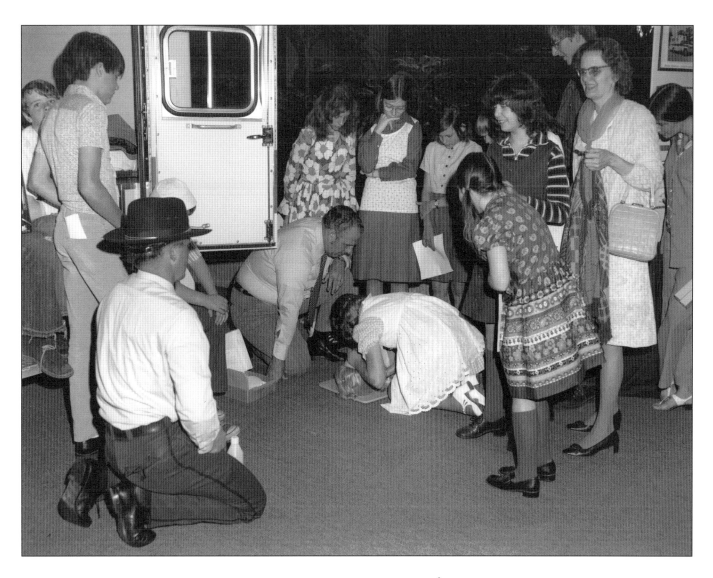

TVA public safety officer oversees first aid procedures at health and safety exhibit at West Town Mall, Knoxville, Tennessee. May 3, 1973. (KX-10660)

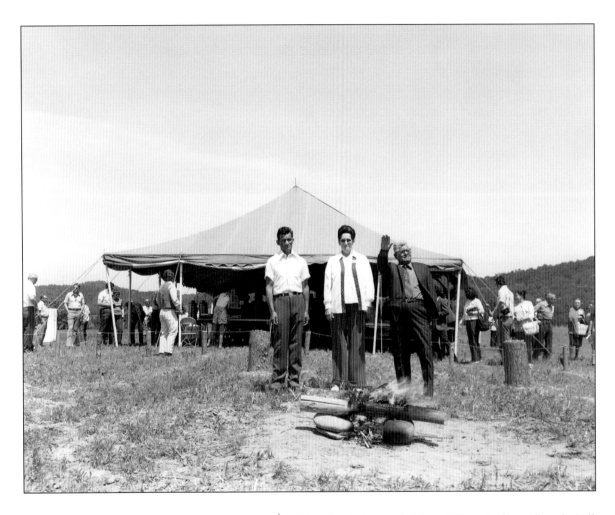

Cherokee Indians visit Chota Village site located on the Tellico Reservoir. On May 10, 1973, a delegation of over one hundred Cherokee Indians from the Qualla Reservation, located in western North Carolina, met with TVA's board at the Chota site in east Tennessee. Religious ceremonies were held, after which a Cherokee elder rekindled the council fire on the spot where the hearth had stood over two hundred years ago when the council house was the center of the Cherokee Nation. May 10, 1973. (KX-10665)

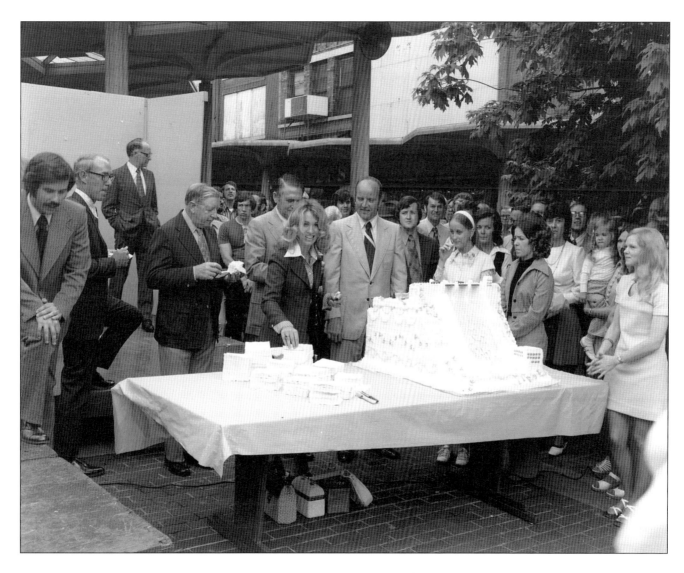

TVA's fortieth anniversary celebration on Market Square Mall, Knoxville, Tennessee. Note the lovely birthday cake in the shape of Norris Dam. May 11, 1973. (KX-10782)

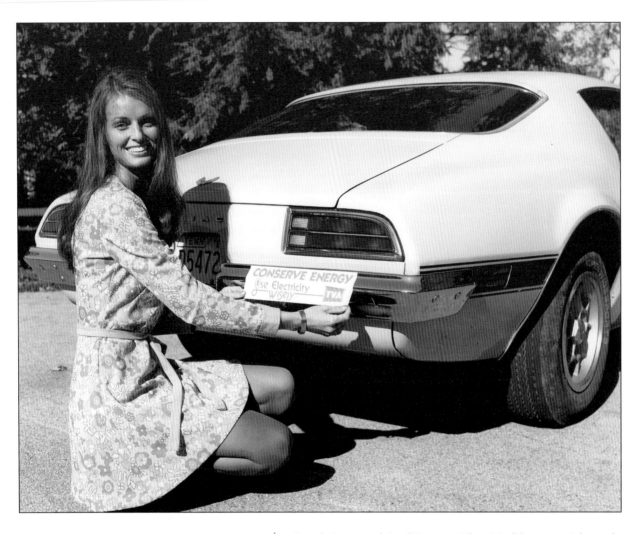

New Challenges,
1963–1978

Brenda Jones applying "Conserve Electricity" bumper sticker to her car. An increasingly tight
coal supply prompted TVA to request that consumers voluntarily curtail the use of electricity
in the Tennessee Valley region to help reduce the possibility of energy shortages during the
winter of 1973–1974. Bumper stickers were one method used by TVA to get its conservation
message out to the public. November 1, 1973. (GR-73186)

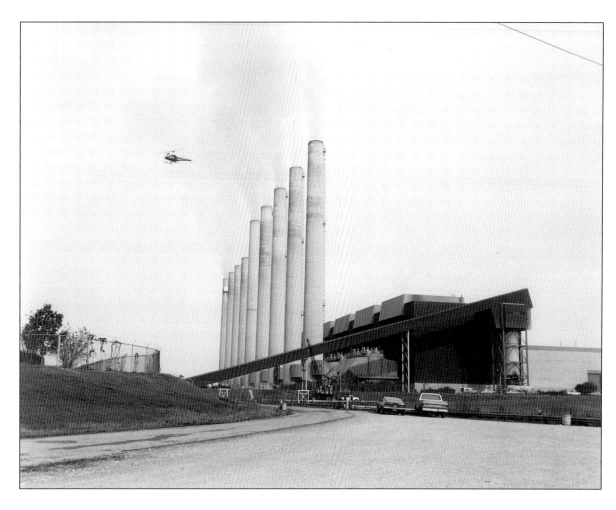

Helicopter measuring emissions from Kingston Steam Plant, Kingston, Tennessee. TVA's Sulfur Dioxide Emission Limitation (SDEL) programs relied on very high plant stacks supplemented by other operational controls to keep sulfur dioxide concentrations within safe limits at ground level, where plant life and human health could be adversely affected. The SDEL programs were the culmination of many years of scientific study of stack plumes and their behavior under varying meteorological conditions. December 1, 1973. (GR-73238)

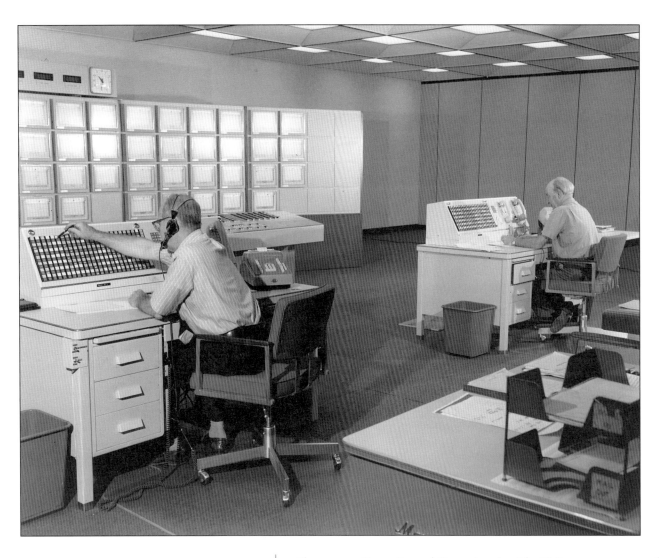

Chattanooga Power Control Center interior. The TVA power system, and the nation's electric utility industry, entered one of the most critical periods of its history in fiscal year 1974 due to the short supply and rising cost of fuels, particularly coal. TVA sold 106 billion kilowatt-hours of electricity during this year. May 1, 1974. (GR-74051)

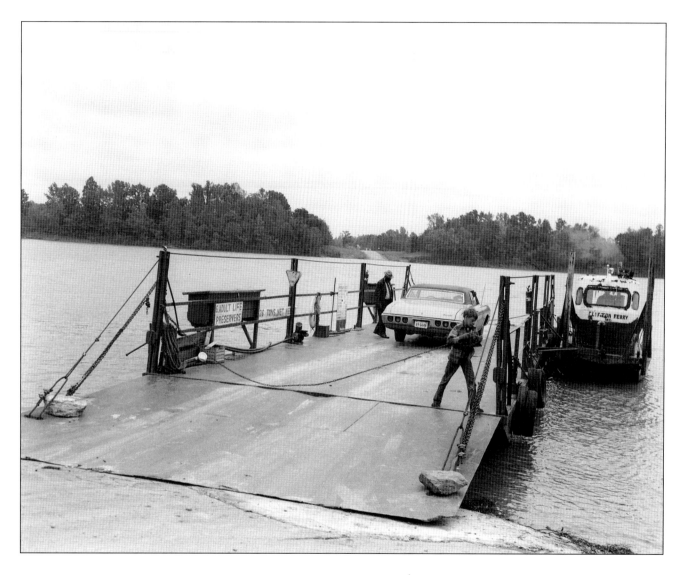

Clifton ferryboat, Kentucky Reservoir. One of the last eight ferries operating in Tennessee, the Clifton ferry, established in 1818, could carry six large cars at one time, roughly forty-five to fifty cars per day. Such conveyances are quite rare today. May 5, 1974. (GR-74064)

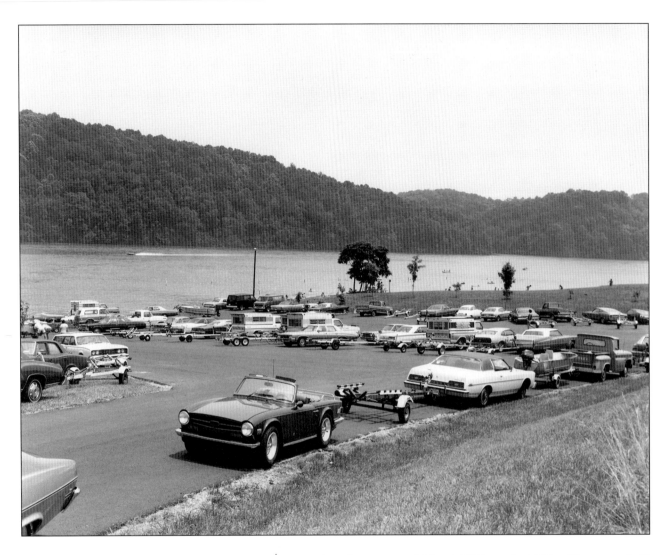

New Challenges,
1963–1978

Boat launching ramp at Melton Hill Dam, Oak Ridge, Tennessee. As illustrated by the number of parked cars on this summer day, TVA reservoirs and shorelines continued to be the focal point for much of the outdoor recreation in the Tennessee Valley. In calendar year 1974, TVA counted a record-breaking 61.9 million visits to its reservoirs. June 30, 1974. (GR-74196)

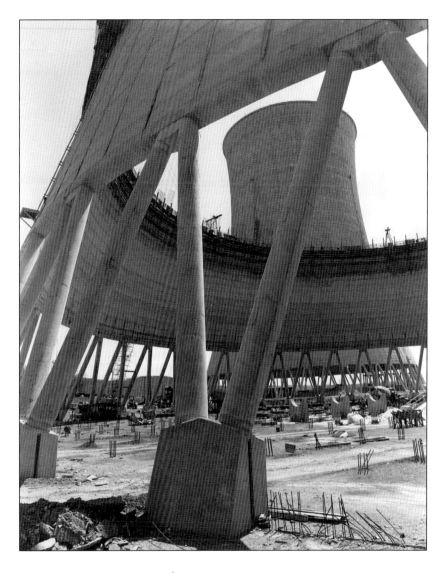

Construction view through #2 cooling tower looking toward #1 cooling tower, Watts Bar Nuclear Plant, Spring City, Tennessee. TVA installed cooling towers at all of its nuclear plants to protect aquatic life from the effects of heated water discharges. April 7, 1975. (GR-75008)

TVA towers under construction, Knoxville, Tennessee. In March 1976, TVA consolidated its employees from twenty-five scattered office buildings in the downtown area into its twin towers headquarters. By housing all area employees under one roof, the agency sought to improve work flow and communications and provide better access to the public. April 17, 1975. (GR-75011)

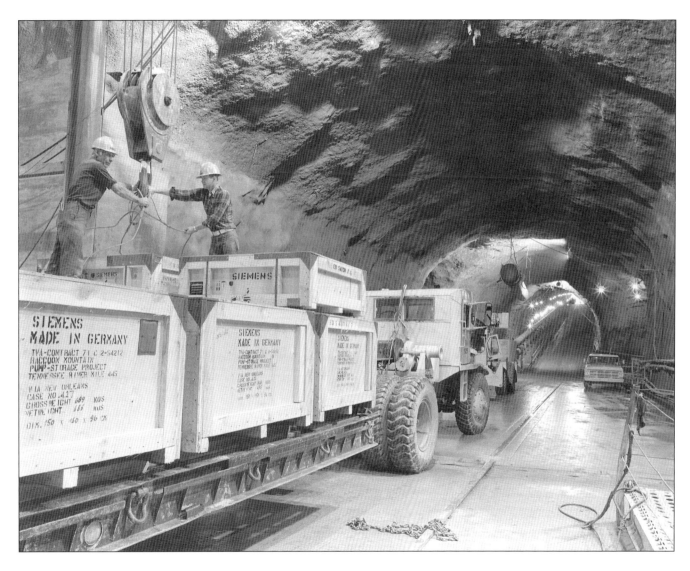

Unloading equipment in powerhouse-construction area at Raccoon Mountain Pumped Storage Facility. To build this plant near Chattanooga, Tennessee, TVA drilled a tunnel, shown here, sixteen hundred feet horizontally into the base of the mountain. June 20, 1975. (GR-75053)

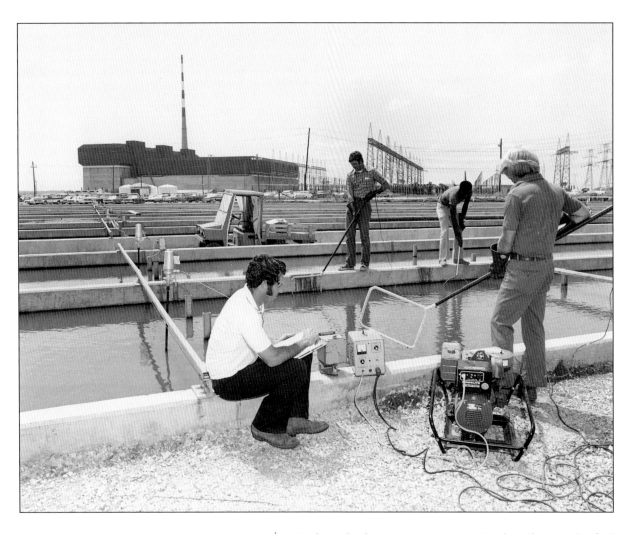

Biothermal Laboratory, Browns Ferry Nuclear Plant. At this facility TVA began long-range studies of the effects of heated water on fish and other organisms found in the reservoir. The modern research lab was a joint project of the Environmental Protection Agency and TVA, and its facilities were among the finest in the world. Shown here are biologists with electric shocking gear collecting fish in biothermal channels. June 18, 1975. (GR-75062)

Bulk storage of 11-55-0 ammonium phosphate dried by a new chemical heating process at TVA's National Fertilizer Development Center at Muscle Shoals, Alabama. This new process eliminates a separate drying step with subsequent savings of fuel, such as natural gas or fuel oil, that normally would be used to dry the product. June 18, 1975. (GR-75067)

Columbia Dam model at Hydrology Laboratory, Norris, Tennessee. TVA engineers and technicians built scaled models of proposed hydro-generating facilities to monitor effects on the river system. Construction began on this dam, located on the Duck River in Maury County, Tennessee, in 1973. Much like the Tellico situation, construction efforts were halted in 1983 because of the potential impact on endangered species. In 1995, after conservation efforts for the endangered mussel species failed to meet established criteria, TVA decided that Columbia Dam and Reservoir could not be completed. Columbia has the distinction of being the only dam built by TVA and, later, dismantled. August 1975. (GR-75121)

TVA insulation demonstration truck for low-income housing, New Tazewell, Tennessee. TVA furnished technical assistance to eighty-one families across the region in exchange for information on the electricity habits of these families. Information about the electricity usage and savings from this program was made available for electric power users throughout the region. June 11, 1976. (GR-76112)

Tennessee Valley Bicentennial South Caravan Exhibits. In cooperation with the state bicentennial commissions and the National Guard, TVA created a traveling exhibit that brought the history, culture, and development of the South to hundreds of thousands of people throughout the Tennessee Valley. This exhibit also established TVA's Bicentennial Volunteers, TVA retirees who volunteer their time for various projects. June 14, 1976. (GR-76116)

Crane operator, construction worker, Watts Bar Nuclear Plant. When this photograph was taken, TVA employed almost thirty-eight thousand people. Many of these employees were construction workers. October 21, 1977. (GR-77169)

New Challenges,
1963–1978

Aubrey "Red" Wagner, TVA chairman, on the way to his final board meeting, Knoxville, Tennessee. Called "Mr. TVA" by many, Wagner came from Wisconsin to TVA in 1934 to work as an engineering aide in the river-development program. He later headed the navigation and transportation branch and served as both assistant general manager and general manager before he was appointed to the board. He was designated chairman in 1962 and served in that position for an unprecedented sixteen years. May 17, 1978. (GR-78054)

The TVA information line, Knoxville, Tennessee. These toll-free phone lines, which served the citizens of the seven valley states, were answered by public information coordinators who responded to public inquiries quickly. From left to right are Janene Drummond, Carolyn Acuff, Karen Tallman, Mary Thomas, Anita Delius, and Brenda Carnes. August 1, 1978. (GR-78098)

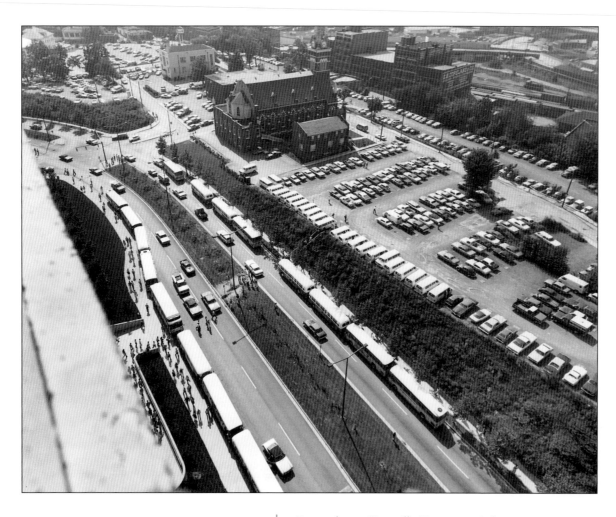

Express buses, Knoxville, Tennessee. A demonstration commuter van pooling service organized by Knoxville TVA employees contributed significantly to a major effort to reduce the use of individual cars by employees going to work. The van program, coupled with improved city express bus service and a computer-matched carpooling program, resulted in a significant reduction in the number of TVA employees driving to work alone, thereby reducing gas consumption and easing the demand for downtown parking spaces. October 1978. (GR-78105)

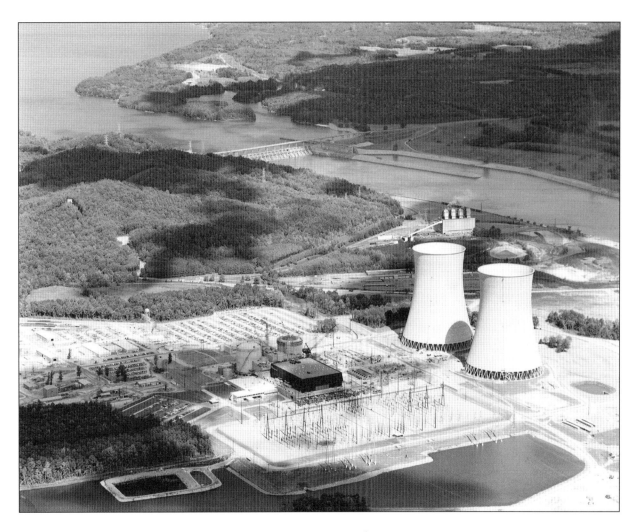

Watts Bar Nuclear Plant showing steam plant and dam. Construction of Watts Bar Nuclear Plant, near Spring City, Tennessee, began in December 1972. Each of the plant's two units has a generating capacity of 1,270,000 kilowatts. Watts Bar Reservoir is the only TVA site where a hydroelectric dam, a coal-fired steam plant, and a nuclear power plant are located together. October 6, 1978. (GR-78174)

Increasing Pressures, 1979–1992

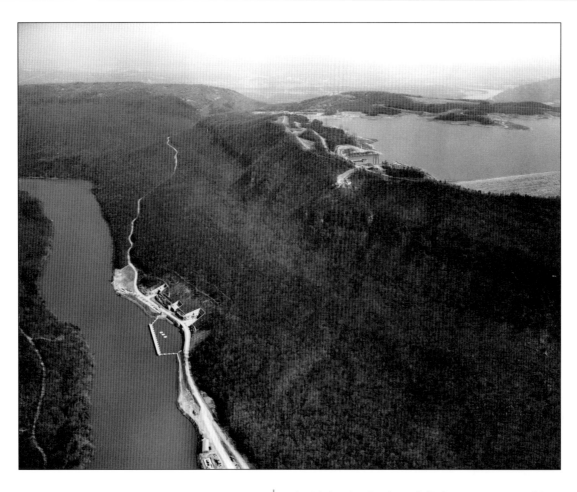

Increasing Pressures,
1979–1992

Aerial showing intake and discharge structures of Raccoon Mountain, TVA's pumped-storage facility. Construction began on this project in July 1970 and was completed eight years later. Located about six miles west of Chattanooga, Tennessee, the project provides 1.5 million kilowatts of capacity to meet peak loads. An 8,000-foot-long dam along the curving mountaintop creates a 528-acre storage reservoir which, during off-peak periods, is filled with water pumped from Nickajack Reservoir below. The water is then released to meet loads during peak electric usage times. March 5, 1979. (GR-79010)

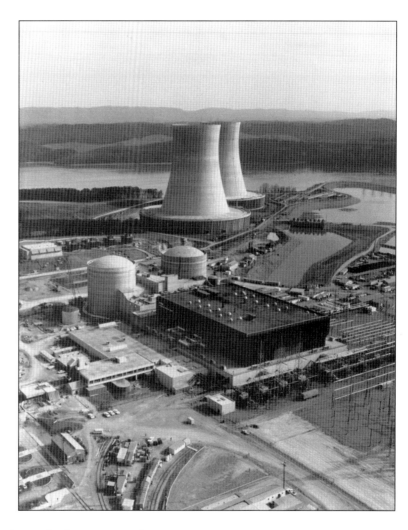

Sequoyah Nuclear Plant, located on Chickamauga Reservoir eighteen miles north of Chattanooga. Construction on the plant started in 1969. Unit 1 went into commercial operation in July 1981, and Unit 2 followed in June 1982. Each unit is a Westinghouse pressurized water reactor capable of generating 1,220 megawatts. Sequoyah is TVA's second nuclear plant to go into commercial operation. March 5, 1979. (GR-79030)

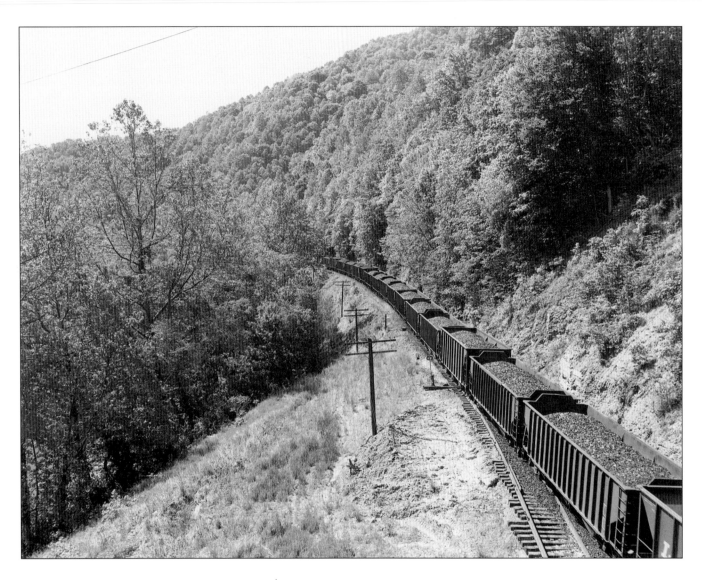

Increasing Pressures, 1979–1992

Coal train near Haddix, Kentucky, bound for Bull Run Steam Plant. In 1979 about two-thirds of TVA's power supply came from coal, and the cost for the coal burned in TVA's power plants was about six times what it was at the beginning of the decade. May 16, 1979. (GR-79041)

Richard "Dick" Freeman greets Imelda Marcos, first lady of the Philippines, at Knoxville's McGhee Tyson Airport. TVA officials briefed Marcos on the agency's programs as she confirmed her interest in starting something similar to TVA in her country. She expressed much interest in recycling of forests and was particularly interested in programs which used wood for energy production. October 31, 1979. (GR-79206)

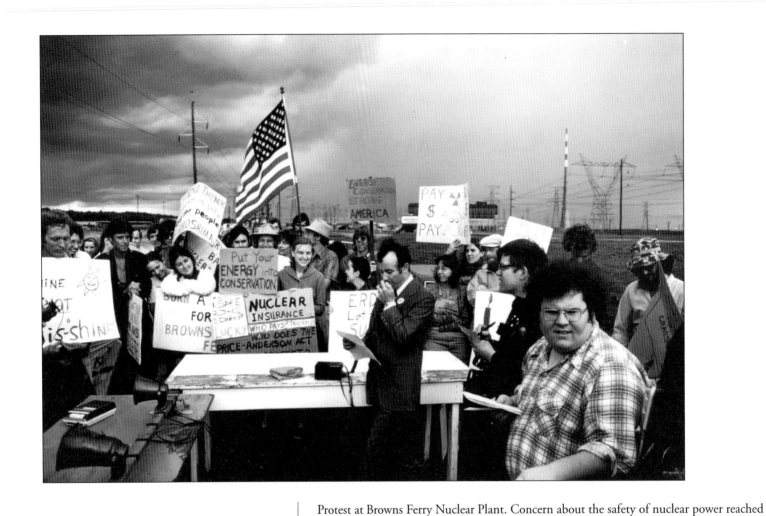

Protest at Browns Ferry Nuclear Plant. Concern about the safety of nuclear power reached a historic peak during 1979 following an accident at the Three Mile Island Nuclear Plant in Pennsylvania. Protesters, shown above, voiced their opinions by participating in an anti-nuclear rally in north Alabama. Shortly afterward in a speech to the Oak Ridge Branch of the American Nuclear Society, TVA General Manager Bill Willis concluded that TVA was working to put aside the public concerns with nuclear energy so that nuclear could play a larger role in fulfilling the energy needs of the country. August 1979.

TVA's solar program demonstration house, Corinth, Mississippi. As part of its energy con-
servation program, TVA developed passive solar designs for homes, winning a competition
sponsored by the U.S. Department of Housing and Urban Development. Solar features on this
home included sliding wooden panels and water-filled tubes, like those shown above, which
absorb and retain heat from the sun. TVA's goal for its solar program was twofold: conservation
and education. June 1981. Photographer: David Luttrell. (GR-82009)

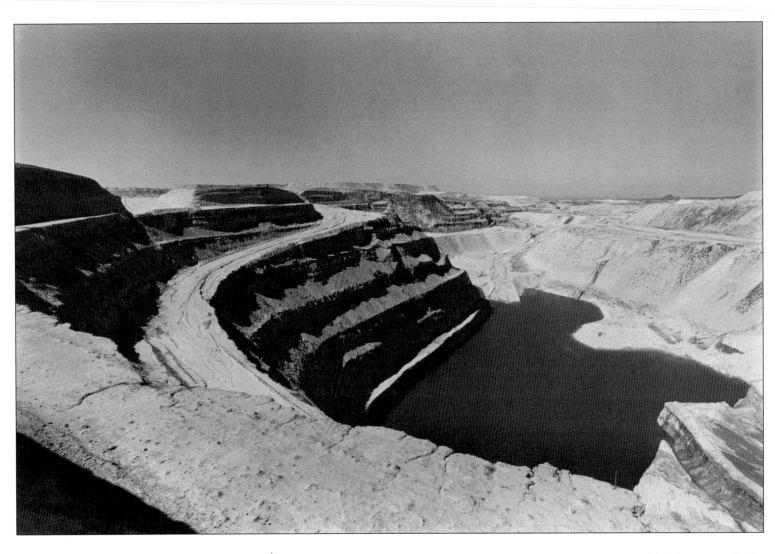

{98} Increasing Pressures,
1979–1992

A terraced open pit mine in the Gas Hills, Wyoming, area, near Casper. To help ensure reliable fuel supplies for its nuclear projects, TVA staked its claim on western uranium mining reserves. Fifty people worked in TVA's Casper, Wyoming, branch, including clerks, geologists, and mining engineers. November 1981. Photographer: Robert Kollar. (3767-6A)

Construction worker. Hit hard by a national recession, a slump in power sales, and an over projection of future power demand, TVA was forced to find ways to save money in 1982. One of the ways it cut costs was a 20 percent reduction in TVA employment, affecting virtually all categories of employees from management to blue-collar construction, operating, and maintenance forces. TVA employment dropped from a peak of over fifty-three thousand in April 1981 to fewer than forty thousand by September 1982. January 1982. (3971-9)

TVA board members (from left to right) Richard Freeman, Charles H. "Chili" Dean, Jr., and David Freeman listen to George Kimmons, manager, Office of Engineering Design and Construction, at board meeting, Knoxville, Tennessee. Studies done in 1982 confirmed that the outlook for electricity sales was very low compared to the estimates projected in the early 1970s. The same studies showed that the tremendous costs required for the nuclear construction program were raising TVA power rates to higher levels. The board agreed at this meeting to defer construction indefinitely on Hartsville A Units 1 and 2 and Yellow Creek Unit 1. In August, the board also decided to cancel Phipps Bend Units 1 and 2 and Hartsville B Units 1 and 2, which had been deferred earlier. March 4, 1982. (4034-27)

Listening session held at the Rural Electrification Administration, Jackson Building, Paris, Tennessee. By the early 1980s, TVA was increasingly under fire by members of Congress. The directors enacted a series of steps to convince congressmen that the agency was being effectively managed. One step called for increased public involvement, such as the holding of "listening sessions" attended by board members and the public and allowing greater opportunities for public comment on rate decisions and operating plans. Here local resident Jack McAdams speaks his mind. March 30, 1982. Photographer: Robert Kollar. (4076-28)

"The Valley Adventure," TVA's exhibit at the 1982 Knoxville World's Fair. Here employees, retirees, and their families attend ribbon-cutting ceremonies before making the first official tour of the exhibit. In 1983, in honor of TVA's fiftieth anniversary, this barge traveled the length of the Tennessee River and stopped at twenty-two communities along the way. April 30, 1982. (4162-4)

Visitors to the Knoxville World's Fair tour TVA's "Valley Adventure" barge exhibit. One of the more popular sites at the fair, over a million people visited the barge. Here Captain Nat Phillips entertains the crowd with his stories about the region's history. August 1982. (4455-35)

TVA divers collect birdwing pearly mussels for transport from the Columbia Dam area to escape habitat changes when the reservoir fills. These mussels were on the endangered species list. This precaution was in vain, as the reservoir was never filled and the dam was eventually dismantled. October 5, 1982. Photographer: David Luttrell. (4496-30)

Phipps Bend auction near Surgoinsville, Tennessee. Approximately 4,000 people turned out for this sale of surplus materials, and of these, 976 submitted bids which totaled $259,625. Part of the Investment Recovery Program organized in 1981, this was the first in a series planned for the agency's shut-down nuclear projects. In 1983 and 1984, this recovery project recouped about $200 million in sales and transfers of equipment. October 1982. Photographer: Robert Kollar. (4544-8)

Energy-saving home, Karns Community. Presented by the Greater Knoxville Home Builders Association, this 1,056-square-foot house took center stage in the annual Parade of Homes. Billed as an "affordable" home, the forty-nine-thousand-dollar house featured energy-efficient techniques from TVA's Energy Saver Program. December 7, 1982. (4593-7)

Stacked bags of ammonium nitrate fertilizer. TVA continued to be a leader in fertilizer research until the 1990s, when the agency refocused its business at Muscle Shoals to emphasize environmental research, development, and demonstration programs. In 1994 TVA renamed the National Fertilizer and Environmental Research Center, which became the TVA Environmental Research Center. January 1983. (4628-21)

TVA employees enter the computer age in the form of the Wang. Circa 1983. (4830-30)

International visitors. These Chinese officials from the Ministry of Water Resources traveled the Tennessee Valley as part of their seminar on the unified resource development of the Tennessee River watershed. Here the officials tour Fort Loudoun Lock and Dam in east Tennessee. April 14, 1983. Photographer: Robert Kollar. (4975)

Senator Jennings Randolph, West Virginia, celebrates TVA's fiftieth anniversary. Randolph, standing in front of the fiftieth anniversary U.S. stamp, was the only remaining member of Congress who was serving when the TVA Act was passed. May 18, 1983. Photographer: Robert Kollar.

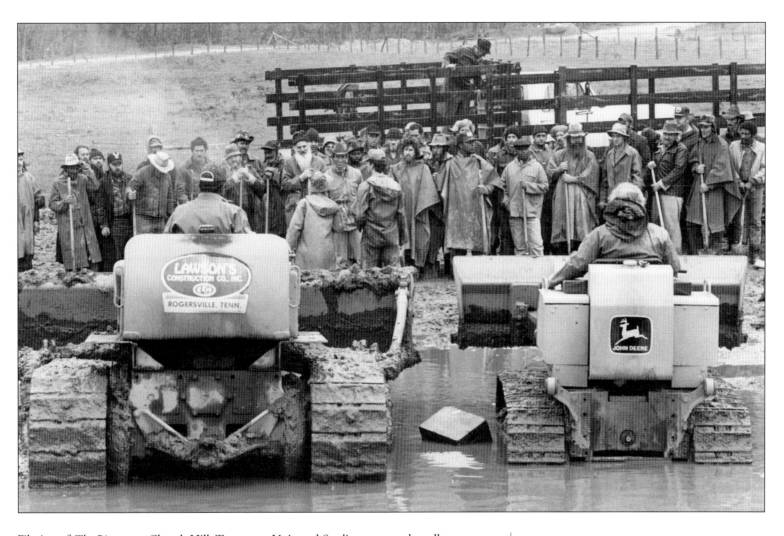

Filming of *The River* near Church Hill, Tennessee. Universal Studios came to the valley to create a controlled-flood situation, and TVA engineers gladly designed a temporary, rock-filled weir to back up the waters of the Holston. Shown above is the filming of the climactic confrontational scene. In the middle of picture are stars Mel Gibson, Sissy Spacek, and Scott Glenn. November 1983.

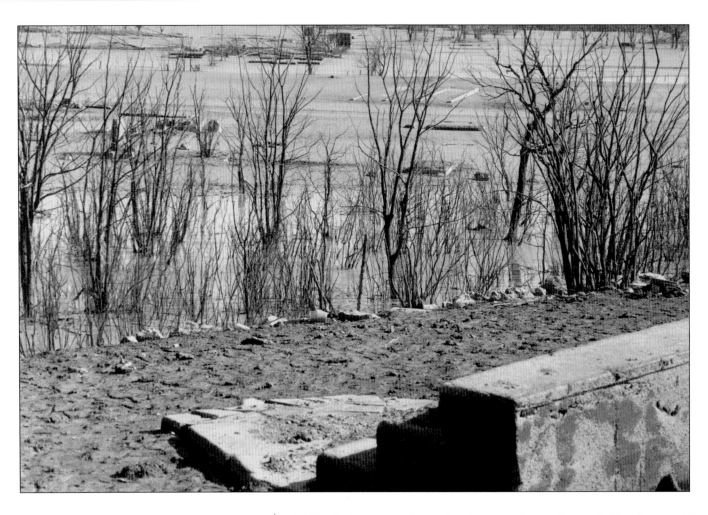

Old Butler, Tennessee, during drawdown of Watauga Reservoir. TVA lowered this reservoir drastically to allow for repairs on Watauga Dam. The exposure of the reservoir bottom and town site, shown above, created major interest among locals. Former Butler residents held a homecoming celebration, and many drove their cars on forgotten roadbeds. When TVA acquired Butler in 1947, it was an incorporated town of roughly six hundred people. December 1983. Photographer: Robert Kollar. (5143-5)

Chattanooga Office Complex (COC). One of the largest passive solar energy projects in the country, the COC housed about 2,650 employees. To increase operational efficiency and employee productivity, TVA consolidated all Chattanooga Power and Engineering employees into one location. Employees moved into the building in 1985. Circa 1985.

**Increasing Pressures,
1979–1992**

Nissan plant, Smyrna, Tennessee. Nissan Motor Manufacturing Corporation, U.S.A, opened its small truck plant in Smyrna in 1983. Bringing industry to the region remains part of TVA's mission today. Circa 1985.

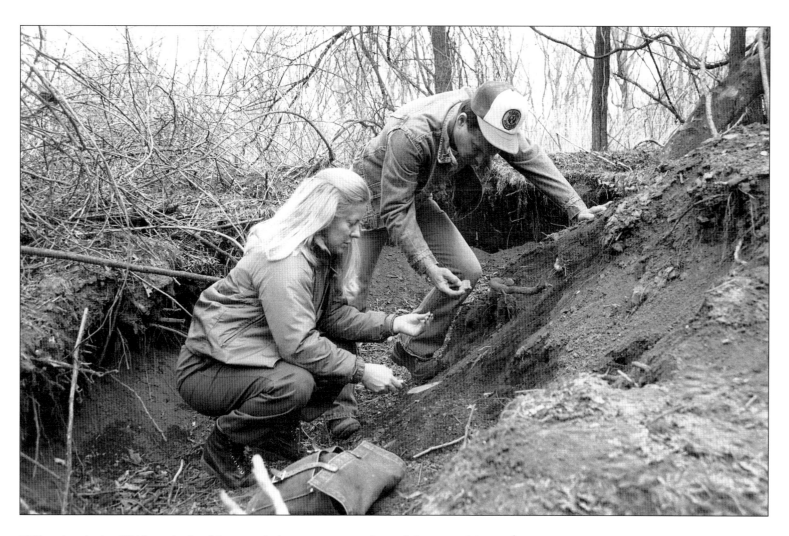

TVA archaeologists Jill Elmendorf and Bennett Graham inspect unauthorized digging on TVA land. Looters, or "pot hunters," recklessly dig up public land in search of ancient pottery and other valuable artifacts. TVA is committed to protecting the cultural resources in the Tennessee Valley, and works diligently to curtail looting. Unauthorized digging along TVA's shorelines or reservoirs is illegal and should be reported to the TVA police. March 1988. (7656-32)

Employees watch and listen to Chairman Marvin Runyon's speech regarding retirement incentives. Runyon announced TVA's restructuring in April 1988 and announced an agency-wide reorganization in May. He stated that "TVA is embarking on a new way of doing business that will make the agency more competitive, more efficient and more focused on its work." This new method of business would include holding the region's power rates steady for three years (ultimately ten) and cutting overhead throughout the agency. It also necessitated a substantial reduction of the workforce. A total of 7,817 employees left the agency, either voluntarily or involuntarily, by the end of September. June 9, 1988. (7795-7)

Dedication of turbines at Pickwick Dam. Some of the twenty-three hundred men and women who built and operated Pickwick Dam gathered for a fiftieth anniversary celebration of the facility's power production. A key part of this celebration was the unveiling of one of the powerhouse's original turbine runners for display. Since it began operation, Pickwick has produced more than 57 billion kilowatt-hours of electricity. June 29, 1988. Photographer: Ron Schmitt. (7820-32)

Sign at Knoxville Job Fair. TVA outplacement officials organized job fairs in Chattanooga and Knoxville, Tennessee, and Huntsville, Alabama, to help place employees affected by the reduction in force. These gatherings were attended by 6,749 TVA employees, who left a total of 32,249 resumes with 251 employers. July 26, 1988. (7840-35)

State-record-holding brown trout caught in Clinch River below Norris Dam. This twenty-eight-pound, twelve-ounce fish broke the thirty-year record for the biggest brown trout caught in Tennessee. Here Mike Smith of the Tennessee Wildlife Resources Agency (TWRA) measures the great fish as TVA's Harry Bales watches. TVA and TWRA placed the fish in the water in September 1982, when it was 4.5 inches long, and when it was caught six years later by Greg Ensor of Powell, Tennessee, it had grown to 32.75 inches in length. Fish stocking, done in partnership with other state and federal agencies, takes place both in reservoirs and tailwaters, providing an indication of water quality and fish habitat conditions. The record for the Clinch, set in 1987, had been seventeen pounds, nine ounces. August 31, 1988. Photographer: Cletus Mitchell. (7880-13)

"Keep America Beautiful" tour of public land, an effort to improve the quality of public lands and waterways. TVA retirees and employees join other area residents in picking up litter near Kentucky Reservoir. The tour also went to Fort Donelson, Land Between the Lakes, and Paris Landing State Park. September 10, 1988. (7897-22)

Transmission construction groundmen and linemen raise a sixteen-foot tower extension near Widows Creek Fossil Plant in north Alabama. Between June 1987 and June 1988, TVA placed into service transmission capital projects totaling $75,763,773, the largest TVA undertaking since the mid-1970s when line work for nuclear construction was at its peak. The 1987-to-1988 time span also marked the first time TVA had construction going at three 500-kilovolt substations simultaneously. These crews repeatedly set records, coming in on time and under budget. September 16, 1988. (7902-12)

Keith Morris, a research and development electrical engineer in Chattanooga, works on fiber-optic research. TVA contracted with MCI Telecommunications Corporation to engineer, design, and construct a fiber-optic network linking key valley sites. October 12, 1988. Photographer: Cletus Mitchell. (7945-18)

Cumberland Fossil Plant management efficiency team. Chairman Runyon challenged senior managers to help TVA cut its operating costs by finding ways to improve performance and operate more efficiently. The formation of efficiency teams in all organizations was one approach adopted by management. The team pictured above was charged with finding cost-saving opportunities in such areas as the purchase of equipment and materials and the elimination of duplication of work within fossil/hydro operations and maintenance. November 11, 1988. (7990-24)

Increasing Pressures,
1979–1992

Kingston Fossil Plant. As part of TVA's Total Quality Management (TQM) Initiative, Kingston employees replace tubes in the Unit 4 condenser to improve the unit's heat rate, thus improving work efficiency. May 1991. Photographer: Robert Kollar. (8189-36A)

Reservoir Operations Center, Knoxville. Reservoir operations specialists confer on how best to manage the river system during a rain event that they termed a "minor flood." The average rainfall for the month of June across the valley was 7.74 inches, more than 2.5 times the amount normally received for the period. June 21, 1989. (8247-5)

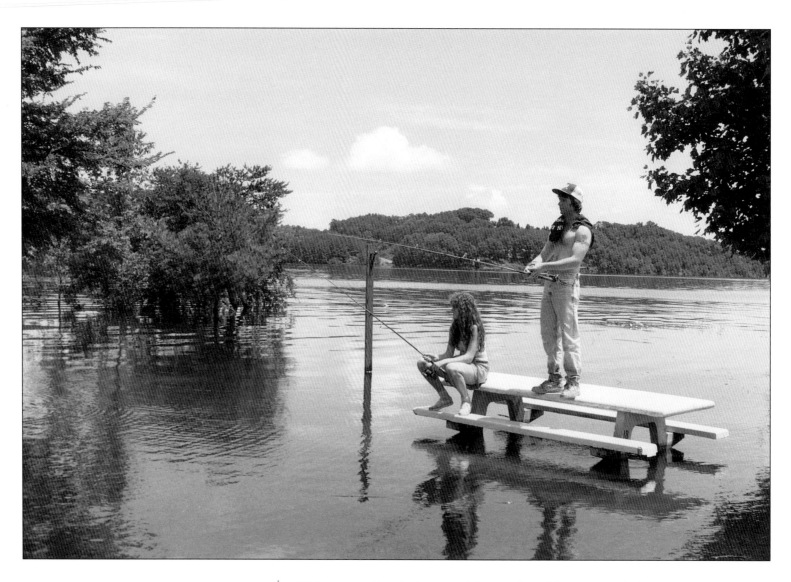

**Increasing Pressures,
1979–1992**

High water on Douglas Reservoir. The record rainfall in June resulted in high water at many TVA reservoirs. Here a picnic table serves as a fishing pier. June 21, 1989. Photographer: Cletus Mitchell. (8249-21)

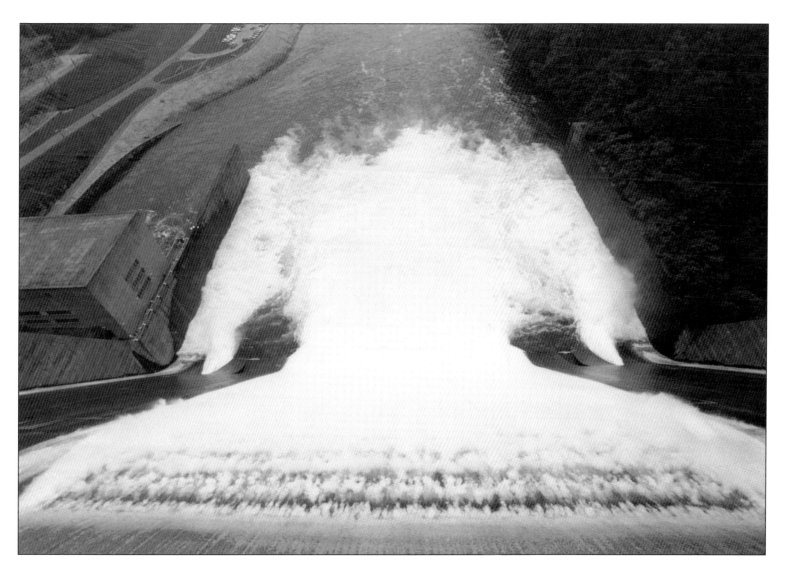

Norris Dam spillway gates releasing water. Thousands visited TVA dams in late June to see the fantastic sight of water spilling. TVA has spilled water at Norris only eight times since 1936. June 23, 1989. (8262-23)

Increasing Pressures, 1979–1992

Celebration at Sequoyah Nuclear Plant. Employees at this plant enjoyed a celebration rewarding them for their teamwork leading to the restart of both units and a major refueling outage, all major accomplishments. July 7, 1989. Photographer: Cletus Mitchell. (8270-27)

Chairman Marvin Runyon signing bonds. TVA issued $4 billion in bonds in the agency public debt market in a move that saves TVA consumers about $75 million annually in interest costs. This was the largest public sale of securities ever undertaken by a U.S. utility and one of the five largest underwritten public debt sales ever undertaken. The bond issue is part of an overall refinancing plan that was estimated to save about $100 million in interest costs. October 19, 1989. (8427-23)

Jet skiers enjoy a TVA reservoir. Recreational opportunities have certainly changed on the waters in the Tennessee Valley. The use of personal watercraft—Jet Skis, WaveRunners, and Sea-Doos—is one of the hottest trends in water recreation. According to the U.S. Coast Guard, more than a million such watercraft are on the nation's waterways. Spring 1990. (8699)

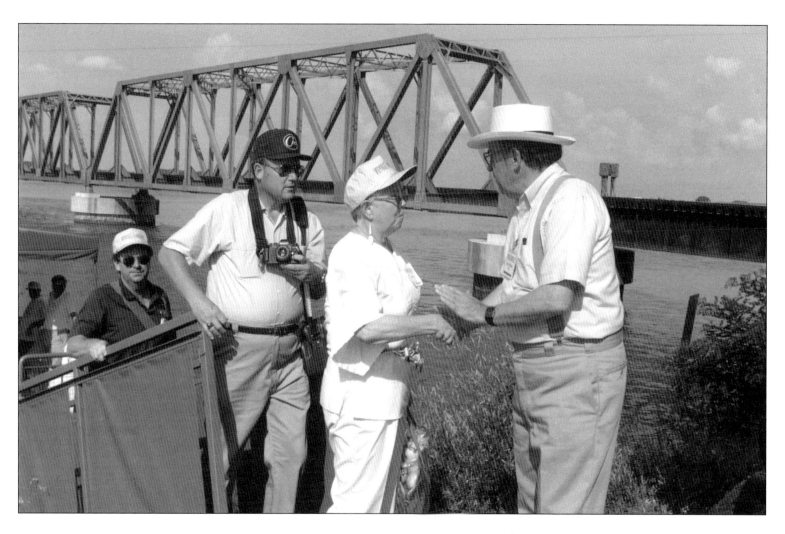

Director John Waters's river tour, day four, Decatur, Alabama, transit dock. On his "Voyage of the Valley" tour, Waters and staff shared information on the river's importance to the Tennessee Valley. It was an appropriate time to inspect the Tennessee, as the board was deliberating on the Lake Improvement Plan, a reassessment of how TVA operated the Tennessee River system. June 7, 1990. Photographer: Cletus Mitchell. (8723-25)

Advanced competitive classrooms, Coalfield, Tennessee. Education as a means of improving valley residents' quality of life has always been important to TVA. By providing new technologies, TVA helps to ready these students for life in the twenty-first century. March 1991. (9106-20)

Russians visit Sequoyah Nuclear Plant (SNP) near Soddy-Daisy, Tennessee. There was no doubt that the Cold War had ended when Soviet nuclear industry personnel visited SNP to study TVA's fire protection program. A U.S./Soviet committee on nuclear reactor safety made international information exchange possible. From left are Nuclear Regulatory Commission official Pat Madden, three visitors from the Soviet Union, Sequoyah vice president Jack Wilson, and Sequoyah plant manager Cal Vondra. The Soviets also visited the TVA Fire Training Academy near South Pittsburg, Tennessee, to observe fire-fighting techniques. March 19, 1991. Photographer: Ron Schmitt. (9121-10)

Competing Demands, 1993–2007

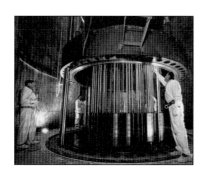 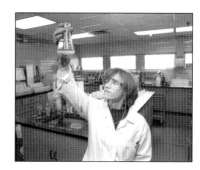

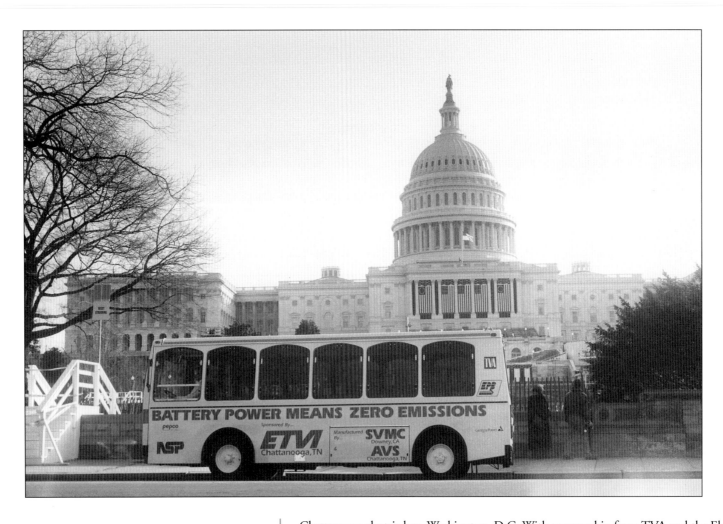

Chattanooga electric bus, Washington, D.C. With sponsorship from TVA and the Electric Power Board, an electric bus from Chattanooga shuttled people around Washington as a demonstration during preinaugural activities. TVA supplied information on electric-vehicle research to the Chattanooga Area Regional Transportation Authority (CARTA) and to Advanced Vehicle Systems, the Chattanooga-based manufacturer of electric buses for CARTA. January 9, 1993. (9890-12)

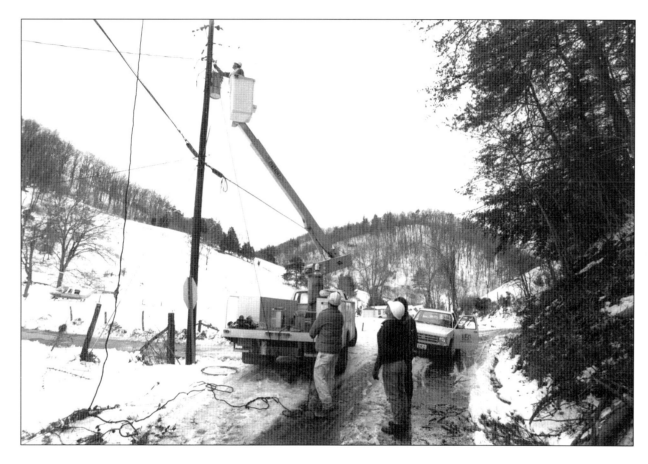

Elizabethton Electric and TVA work together. Many people will remember the weekend of March 13–14 as the time of the "blizzard of 1993." A severe storm dropping as much as thirty inches of snow in some parts of the power service area, with drifts much higher, cut off electricity to about a half million residents and businesses in the Tennessee Valley. Ten TVA transmission lines serving seventeen distributor substations were damaged. TVA crews went to work to restore the power, and fifteen of the seventeen were restored in two to three hours. In more remote areas, TVA brought in crews and equipment by helicopter to fix TVA lines and to aid distributors. March 16, 1993. Photographer: Cletus Mitchell. (9958-10)

Competing Demands,
1993–2007

New TVA sign and logo. As part of renovation efforts at the TVA Towers, and as a way of emphasizing corporate branding, a sign bearing the TVA logo is lifted to the top of one of the towers in downtown Knoxville. Two of the fourteen-foot-high, eighteen-foot-wide, blue and white signs were placed on the East Tower and one on the West Tower during the weekend of July 8–10. The signs remain visible from the interstate and fit in with other corporate signs on buildings on the Knoxville skyline. July 8, 1994. Photographer: Robert Kollar. (10560)

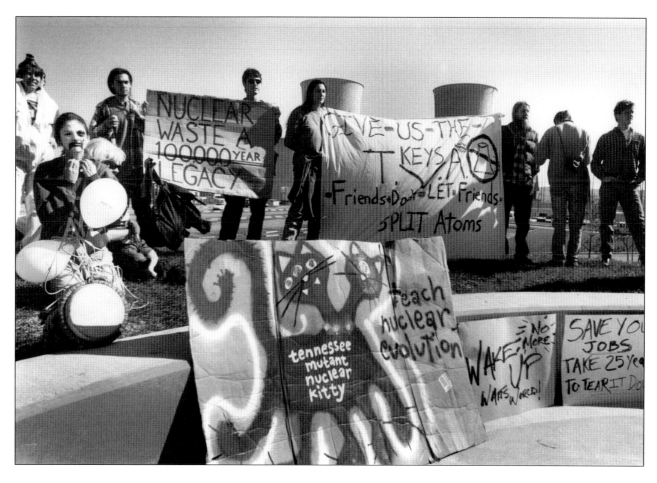

Protesters, Watts Bar Nuclear Plant (WBNP). Members of the Student Environmental Action Coalition display signs in a peaceful antinuclear demonstration. TVA officials and group members worked together to ensure that the protest would be peaceful, and TVA provided bus transportation from the parking lot. In response to the group's earlier claim that "Watts Bar is a lemon," TVA served the protesters lemonade. The sign on the far right, "Save Your Jobs—Take 25 Years to Tear It Down," refers to the agency's restructuring and downsizing. October 29, 1994. Photographer: Robert Kollar. (10752-27)

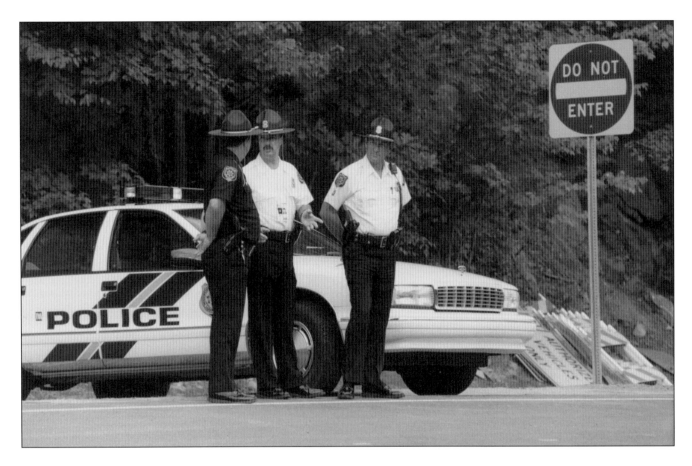

TVA police: Commander Jim Carver (center), Officer Timothy Wigley, and Officer Stanley Ashe. Historically TVA had public safety officers, but on September 12, 1995, 125 men and women pledged to "impartially discharge the duties incumbent upon a federal law-enforcement officer." And the TVA police force was born. TVA police officers provide for the protection of employees at all TVA sites, as well as of the public and TVA property. They maintain law and order on all property under the care and control of TVA, and they have the authorization to carry firearms, seek and execute arrests or search warrants, and conduct investigations. September 1995. Photographer: Barry Williams. (11164-3)

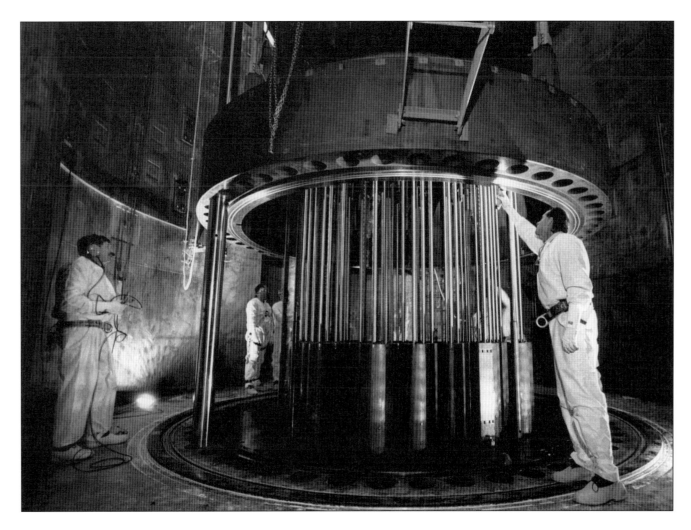

Refueling of Watts Bar Unit 1. On November 9, 1995, Watts Bar Nuclear Plant received a low-power operating license from the Nuclear Regulatory Commission, authorizing the loading of fuel and up to 5 percent operation of Unit 1. Eleven hours later, workers began loading 193 fuel bundles into the reactor. Above, employees set the reactor head on the reactor vessel. November 10, 1995. (11216-3)

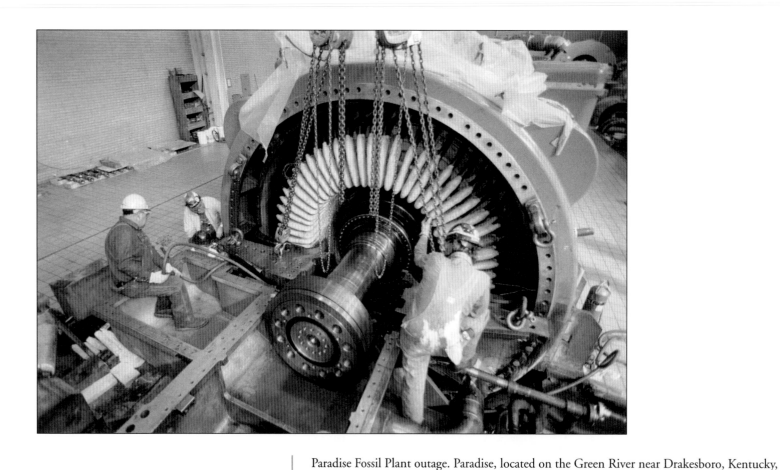

Paradise Fossil Plant outage. Paradise, located on the Green River near Drakesboro, Kentucky, underwent a scheduled outage—a maintenance process to get more power from each gram of fuel and keep the plants operating more reliably. The work at Paradise on Unit 2, which came online in 1963, is a major "megahaul"—a $13.9 million, seventy-eight-day outage which left the unit as if it were brand new. The work will improve TVA's equivalent forced-outage rate and heat rate, help the environment, and improve the structure of the turbine. Above (from left) rigger Beverly Ashby and millwrights Jim Hudson and James Edwards work on the Unit 2 generator during Paradise's scheduled outage. November 6, 1995. Photographer: Barry Williams. (11232-24)

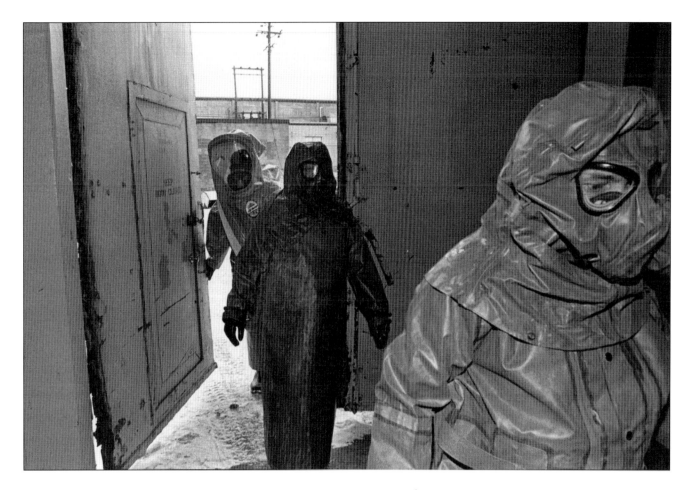

Workers from TVA's Environmental Research Center wear M-17 masks to protect their
respiratory systems at the Rocky Mountain Arsenal near Denver. These employees are part of
the team of workers under contract to the Department of Defense to sample, decontaminate,
and dismantle equipment used to produce chemical warfare agents. The army asked TVA to
get involved in this work because the Phosphate Development Works in Muscle Shoals could
distill DC (methyl phosphoric dichloridel), an intermediate ingredient used in making these
chemical weapons. February 1996. Photographer: Barry Williams. (11400-11C)

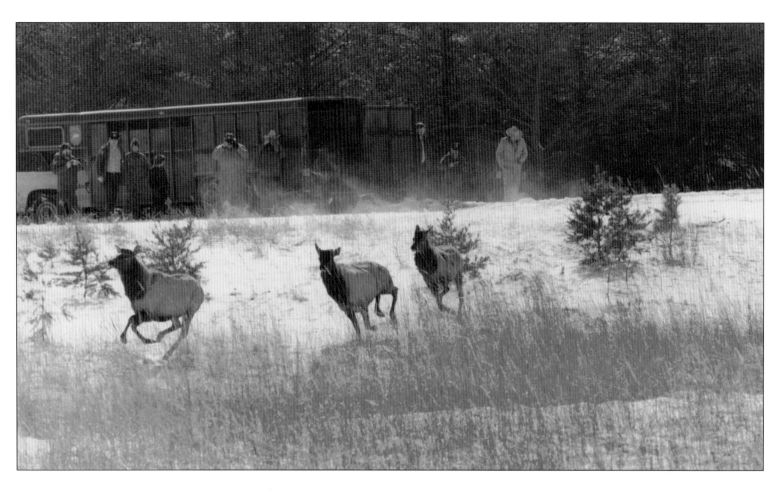

Elk release, Land Between the Lakes. Through a cooperative effort by TVA, private founda-
tions, the states of Kentucky and Tennessee, and Parks Canada, in February 1996 twenty-nine
Manitoban elk were released into a 750-acre enclosure at Land Between the Lakes. This release
was part of an overall effort to reestablish elk where the species has not lived for a century and
a half. Eastern elk had become extinct by 1850, and the Manitoban elk are believed to most
closely resemble the Eastern subspecies that once inhabited the region. February 16, 1996.
Photographer: Robert Kollar. (11452)

Craven Crowell readying for appropriations hearing, Washington, D.C. This was one of the final times TVA would prepare for this hearing, as the agency received its final appropriated funding in FY99. During 1999 TVA received total federal appropriations of $50 million, of which $43 million was for essential stewardship activities and $7 million for TVA's Land Between the Lakes National Recreation Area. March 1996. Photographer: Robert Kollar. (11473-16)

Students from Gene W. Brown Elementary School in Hendersonville, Tennessee, run on a track made of bottom ash from Gallatin Fossil Plant. This is an example of environmentally focused donations TVA makes and volunteer activities in which TVA individuals and organizations participate. After coal has been burned in certain types of coal-fired plants, bottom ash about the size of gravel falls out of the bottom of the boiler. May 1996. Photographer: Barry Williams. (11553-22A)

Melton Hill Reservation maintenance worker. TVA maintains its dam reservations for year-round use by the public. Summer 1996. (11568-26)

Olympic white-water competition, Ocoee, Tennessee. NBC commentator Al Trautwig
welcomed viewers: "The Tennessee Valley Authority has the switch turned on, filling the Ocoee
River bed and creating one of the most beautiful scenes in the Games." For the next two days,
July 27 and 28, the world's best canoeists and kayakers participated in an Olympic competition.
July 27, 1996. (11715-29)

Hydro-modernization, Wheeler Dam. Dickey Howard (left) and Wheeler Dam H-MOD project control engineer Doug Draper receive the new turbine runner to be installed in Unit 9 as part of TVA's hydro-modernization program. This program began in 1992. TVA plans to refurbish and upgrade eighty-eight hydro units by 2019, adding about 536 megawatts of capacity—enough to provide power to about twenty-three hundred homes. July 1996. Photographer: Ron Schmitt. (11753-22)

Regina Youngblood inspects tires at Bridgestone/Firestone, Morrison, Tennessee. Bridgestone/ Firestone–Warren County Plant, a TVA-direct-served customer, won a Tennessee Quality Award by focusing on the value of teamwork, customer satisfaction, and quality. October 30, 1996. Photographer: Barry Williams. (11880-13)

Power service shops electricians Bob Sawyer (left) and Jim Hargrove help assemble Allen Fossil Plant's new transformer. The goal is to move a 550,000-pound fully assembled transformer into place. TVA employees found an innovative, money-saving approach—saving $225,000 in assembly costs and reducing outage time by two weeks. March 1997. Photographer: Lisa Waddell Buser. (12047-26)

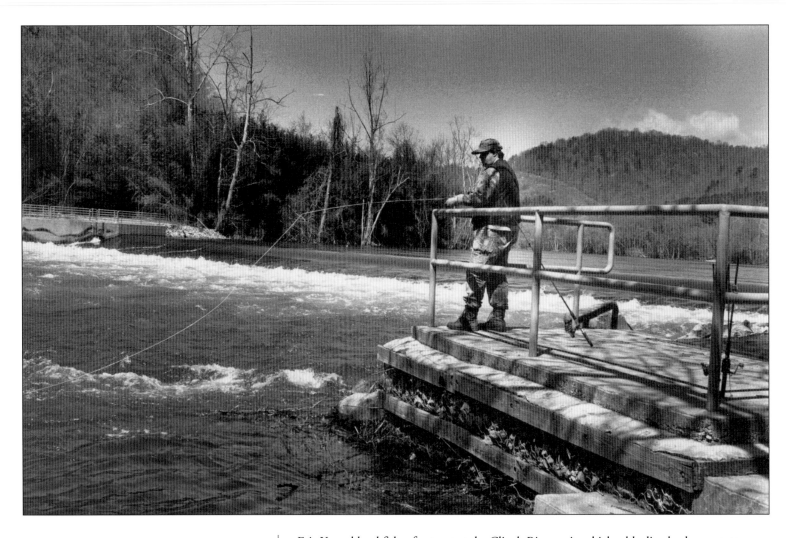

Eric Youngblood fishes for trout at the Clinch River weir, which adds dissolved oxygen to the water below Norris Dam. TVA works to be an environmental leader through its efforts to improve water quality. Programs include controlling non-point-source pollution, restoring oxygen in water released from dams, and constructing wetlands to filter toxic contaminants from groundwater. April 1997. Photographer: Robert Kollar. (12077-6A)

Bull Run Fossil Plant transmission lines. TVA had over sixteen thousand miles of transmission lines in service in 1997. July 15, 1997. (12175-32)

Competing Demands,
1993–2007

TVA Police confiscate two of eighty marijuana plants discovered on TVA property near Tellico Reservoir in east Tennessee. The estimated street value was approximately $120,000. July 28, 1998. Photographer: Steve Morrell.

Firefighters. TVA, through a Memorandum of Understanding with the U.S. Forest Service, provides trained, qualified personnel to help suppress wildfires in the South as well as nationally. At this time, TVA had twenty-two members on the Wildland Fire Management Crew. Shown here are members (front row, from left) Glenn Knight and Greg Broyles; (back row) Randy Short, Joe Hudson, and Jack Muncy. August 1998. Photographer: Robert Kollar.

STAR 7 Chattanooga workshop. STAR 7 is designed to reshape the way TVA works. It encompasses management and operational improvements as well as changes in the way we work together. "STAR" stands for Strategic Teamwork for Action & Results. The "7" represents TVA's seven values. The first step is a leadership, team-building, and cultural-change workshop. The idea is that high-performance culture will help TVA succeed in a more competitive world. The workshop explores concepts that are critical to high performance: teamwork, innovation, accountability, coaching, and constructive feedback. Through a series of exercises and discussions, employees look at their own behavior and figure out if they need to change to be more successful. September 9, 1998. (13293-12)

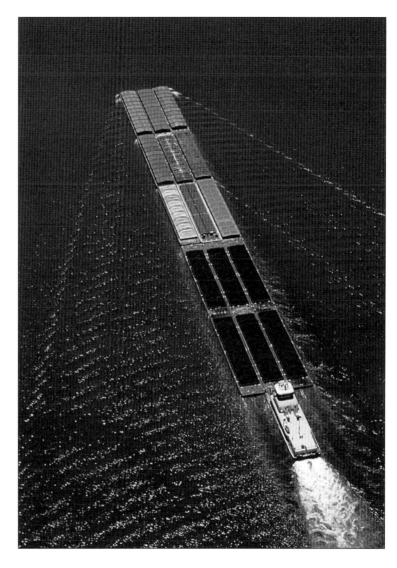

Coal barge on Tennessee River. TVA purchased over 41 million tons of coal in fiscal year 1998 for use in its fossil fuel plants. Summer 1998. Photographer: Cletus Mitchell. (1998.JPG)

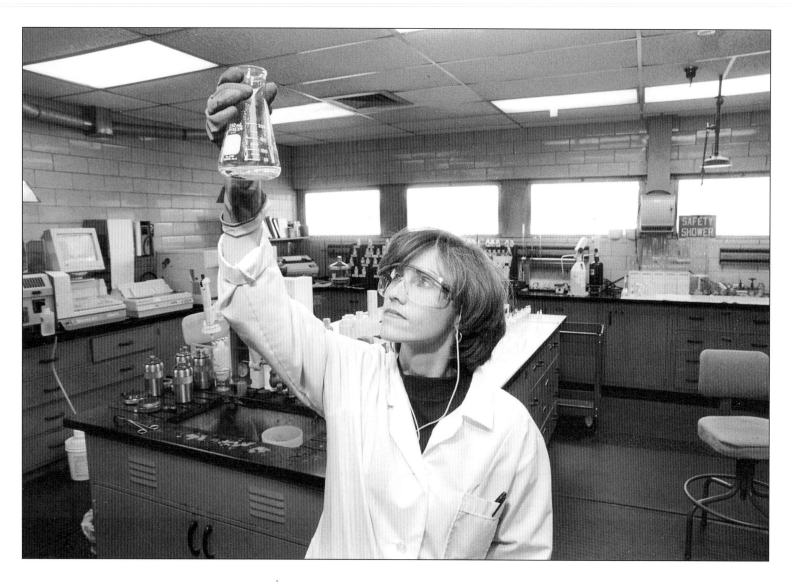

Central Labs, Chickamauga Dam Chattanooga Quality Teams. Analytical chemical lab corrosion product monitoring for TVA plants. February 4, 1999. (13369-5)

The force of nature. Downed transmission lines—a result of the high winds and tornadoes in the Jackson, Tennessee, area. January 1999. (13370-9)

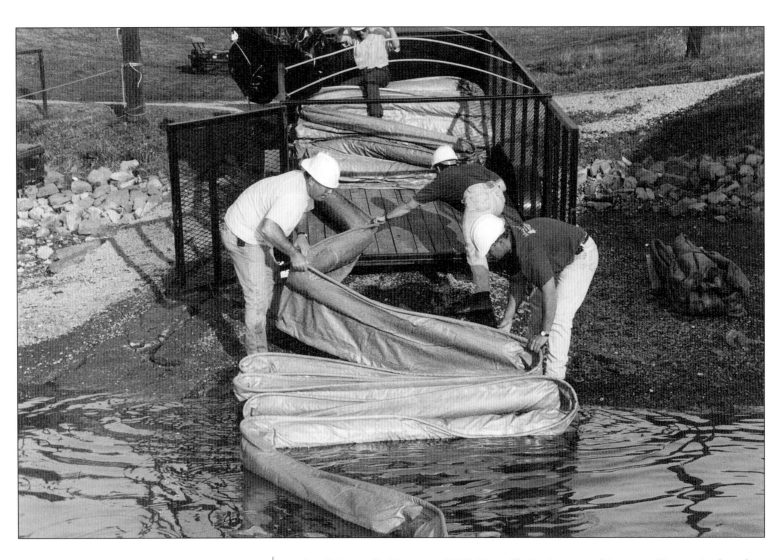

Oil spill, Knoxville, Tennessee. TVA's Knoxville Environmental Response Team arrived on the scene of a diesel-fuel pipeline rupture to help contain the spill. High-sulfur diesel fuel was gushing into the air and spilling more than forty-five thousand gallons into the river. TVA has four Environmental Response Teams. February 10, 1999. Photographer: Robert Kollar. (13386-15)

Environmental Research Center Wetlands scientist Les Behrens checks a reciprocating-wetlands demonstration at the constructed-wetlands facility in Muscle Shoals, Alabama. TVA received a patent from the U.S. Patent and Trademark Office for inventing a cost-effective wastewater-treatment technology that successfully removed pollutants from water in a constructed-wetlands system. TVA operates one of the nation's largest wetlands-development centers at its Muscle Shoals facility. It has more than thirty-two outdoor wetland cells, a large greenhouse, and labs located on four acres. March 22, 1999. Photographer: Hank Houke. (13396-9)

Hot gas decontamination unit, Muscle Shoals, Rick Almond and Terrel Webb. These scientists are successfully demonstrating a technology that can safely eliminate explosive residues, such as TNT, without adversely affecting the environment. The U.S. Department of Defense is partnering with TVA to decontaminate munitions, storage tanks, piping, and other equipment at army ammunition plants, depots, and arsenals throughout the country. The explosives-contaminated equipment and munitions are heated in a hot-gas chamber until the explosive residue is safely removed. May 1999. (13455-3)

Nuclear Exchange Program, Robert Cisamolo, training department manager, Électricité de France's Cattenom Nuclear Plant in eastern France. He visited the Tennessee Valley to learn about TVA and its nuclear plants and management styles. France receives from 75 to 80 percent of its energy from nuclear power. June 1999. (13462-9)

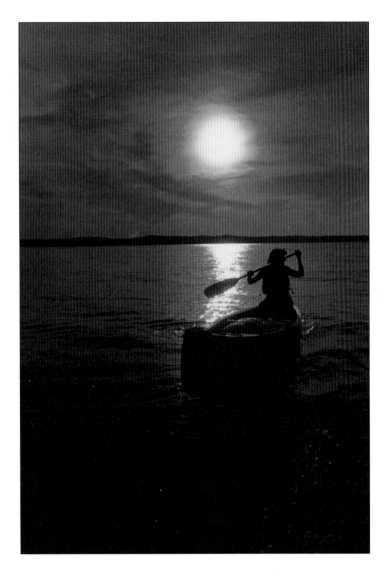

Canoeing at Land Between the Lakes. TVA transferred LBL to the secretary of agriculture on October 1, 1999.

Competing Demands, 1993–2007

River Forecast Center, Knoxville, Tennessee. River Systems Operations senior consultant Morgan Goranflo (right) explains to water conference attendees how River Scheduling puts together the daily operating plan for the TVA reservoir system. More than 150 people, including municipal water suppliers, energy distributors, and government officials, attended TVA's first annual water conference. June 14, 2001. (DP-3)

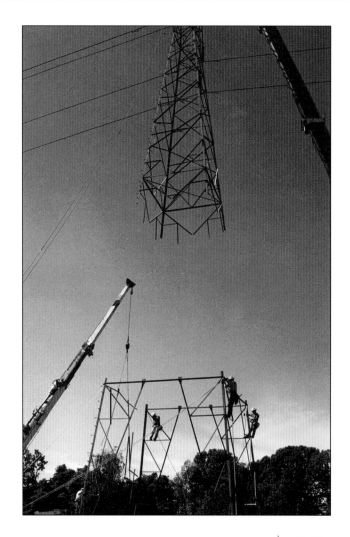

Raising transmission tower, west Tennessee. TVA Transmission/Power Supply (TPS) construction workers raise a 161-kilovolt transmission tower. TVA's transmission system achieved 99.999 percent reliability in FY 2000 and 2001, and TVA and TPS were ranked "best in class" in lost-time injuries in a FY 2000 Edison Electric Institute study in which TVA was benchmarked against forty-one large U.S. utilities. December 2001. (DP-4)

Ash hoppers, Cumberland Fossil Plant. These ash hoppers were installed as part of the selective catalytic reduction system (SCR) process. Installing this system is one more way that TVA works to reduce sulfur-dioxide and nitrogen-oxide emissions from its fossil plants. March 2002. (14011-23)

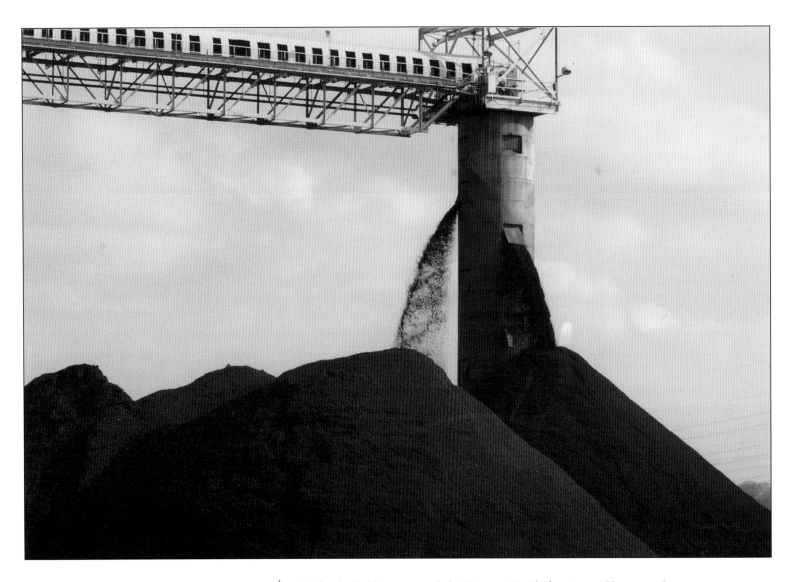

Coal unloaded by conveyor belt, Kingston Fossil Plant in east Tennessee. June 2002.

Photographer: Cletus Mitchell. (DP-5)

Mimi Hughes, marathon swimmer, tackles the Tennessee River. In order to generate public interest in protecting the waters of the Tennessee, Hughes swam the 652-mile length of the river during five summers between 1999 and 2003. TVA coordinated the use of a support boat and helped with logistical needs. Through integrated resource management of the river system, TVA optimizes benefits including flood control, navigation, power generation, recreation, water quality, and water supply. July 2002. (DP-6)

Competing Demands,
1993–2007

TVA hybrid vehicle. (From left) Ken Voorhis, Great Smoky Mountains National Park Acting Superintendent Phil Francis, and Director Baxter examine a Honda Civic Hybrid that TVA loaned to the Great Smoky Mountains Institute at Tremont. The hybrid vehicle was loaned to the GSMIT for one year as part of TVA's continued partnership to reduce emissions in the national park. Since October 2000, TVA has loaned seventeen electric or hybrid vehicles for use in or near the Great Smoky Mountains. December 2002. Photographer: Cletus Mitchell. (DP-7)

Sam E. Hill Preschool. These children represent the valley's future. October 19, 2005. (B7J2588.JPG)

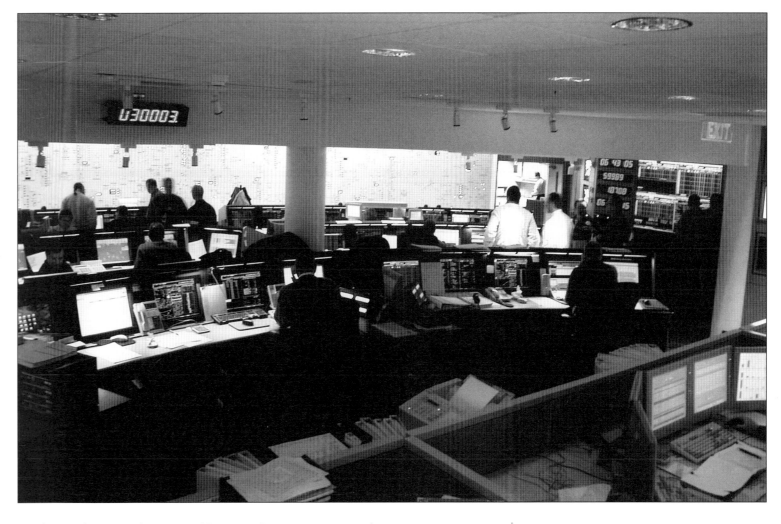

Load Control Center, Chattanooga, Tennessee. On January 24, 2003, the average temperature for the five largest cities served by TVA dropped to six degrees Fahrenheit and pushed demand to new heights. An overhead digital display flashes a figure of more than thirty thousand mega-watts of demand on the TVA power system during the hour of the record peak. January 24, 2003. (1MG-3507.JPG)

Green Power Switch ceremony. Skila Harris, the first woman appointed to the TVA board, welcomes Green Power Switch customers. More public power distributors have joined TVA's renewable-energy program and can now offer it to their customers. TVA's generation facilities include fifteen solar sites, a methane-gas source, and a wind farm. August 5, 2003. Photographer: Cletus Mitchell. (DSC_0063.JPG)

Teaching exercises at TVA's Fire Training Center located on Nickajack Reservoir in southeast Tennessee. 2005. Photographer: Cletus Mitchell. (2005.JPG)

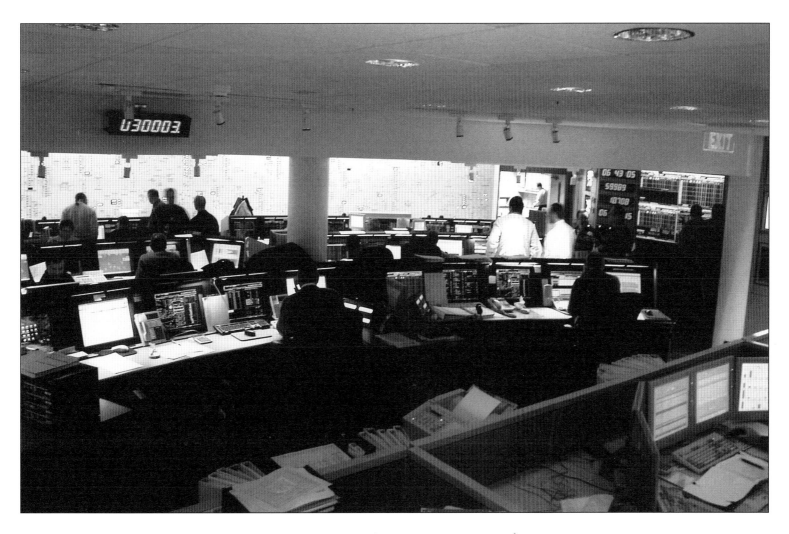

Load Control Center, Chattanooga, Tennessee. On January 24, 2003, the average temperature for the five largest cities served by TVA dropped to six degrees Fahrenheit and pushed demand to new heights. An overhead digital display flashes a figure of more than thirty thousand megawatts of demand on the TVA power system during the hour of the record peak. January 24, 2003. (IMG-3507.JPG)

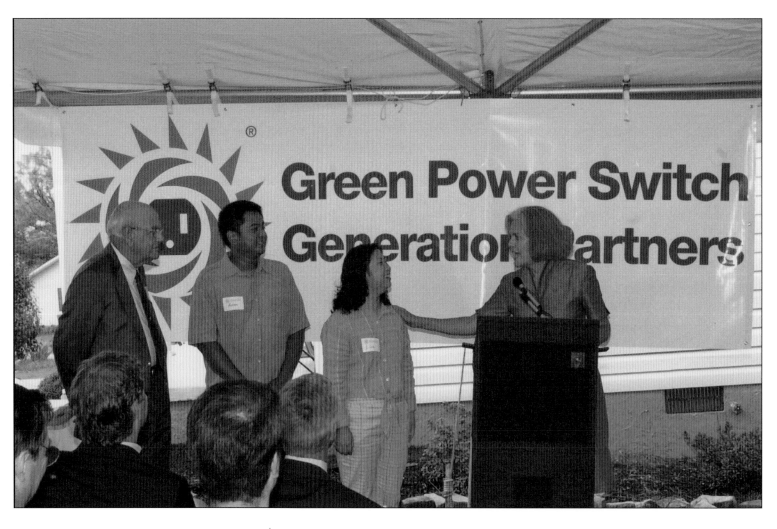

Green Power Switch ceremony. Skila Harris, the first woman appointed to the TVA board, welcomes Green Power Switch customers. More public power distributors have joined TVA's renewable-energy program and can now offer it to their customers. TVA's generation facilities include fifteen solar sites, a methane-gas source, and a wind farm. August 5, 2003. Photographer: Cletus Mitchell. (DSC_0063.JPG)

Teaching exercises at TVA's Fire Training Center located on Nickajack Reservoir in southeast
Tennessee. 2005. Photographer: Cletus Mitchell. (2005.JPG)

Sam E. Hill Preschool. These children represent the valley's future. October 19, 2005. (B7J2588.JPG)

Wind-turbine generators on Buffalo Mountain near Oliver Springs, Tennessee. Electricity from these turbines is sold through TVA's Green Power Switch program that uses electricity generated by renewable resources such as solar power, wind power, and landfill gas. Such technological advancements symbolize TVA's future, one in which TVA performs measurably better than its peers, and TVA's name, harkening back to the early years, will be synonymous with efficiency, sustained value, creativity, and innovation. 2006. (DSCF2311.JPG)

Notes

1. "Warm Greeting in Peaceful Valley for JFK," *Florence (AL) Times*, May 19, 1963.

2. John F. Kennedy, *Public Papers of the Presidents of the United States, January 1 to November 22, 1963*, ed. Warren Reid (Washington, DC: U.S. Government Printing Office, 1964), 406.

3. Ibid., 410.

4. Tennessee Valley Authority, *Annual Report of the Tennessee Valley Authority* (1963; reprint, New York: Arno Press, 1969), 1–3; Richard Lowitt, "TVA, 1933–45," in *TVA: Fifty Years of Grass Roots Bureaucracy*, ed. Erwin C. Hargrove and Paul K. Conkin (Urbana, IL: University of Illinois Press, 1983), 61–62. Not all believe that TVA enhanced the Tennessee Valley. For an in-depth argument, see William U. Chandler, *The Myth of TVA: Conservation and Development in the Tennessee Valley, 1933–1983* (Cambridge, MA: Ballinger Publishing Company, 1984). Chandler challenges the idea that TVA's work in navigation, flood control, and hydroelectric power created unprecedented economic prosperity in the Tennessee Valley. He asserts that instead of aiding the valley, government by authority may have impeded economic growth in the region.

5. *1963 Annual Report of the Tennessee Valley Authority*, 6–8, 62–63.

6. Ibid., 8–15.

7. Kennedy, *Public Papers*, 410.

8. Paul L. Evans, interview by Charles Crawford, tape recording transcript, August 7, 1979, Mississippi Valley Collection, John Willard Brister Library, University of Memphis, 19. Evans served as assistant director of information and/or director of information from 1951 until 1974–75. Also see Wilmon H. Droze, "The TVA, 1945–1980: The Power Company," in Hargrove and Conkin, *TVA: Fifty Years of Grass Roots Bureaucracy*, 66–85.

9. Evans, interview, 18, 32.

10. Tennessee Valley Authority, *Annual Report of the Tennessee Valley Authority* (1964; reprint, New York: Arno Press, 1969), 1–6, and Tennessee Valley Authority, *Annual Report of the Tennessee Valley Authority* (1965; reprint, New York: Arno Press, 1969), xi.

11. *1964 Annual Report of the Tennessee Valley Authority*, 7–9.

12. Tennessee Valley Authority, "A Proposal for a National Recreation Area Between-the-Lakes Formed by Kentucky and Barkley Dams" (Knoxville: TVA, 1961), 2. The *1964 Annual Report of the Tennessee Valley Authority*, 18, cites the findings of the Outdoor Recreation Resources Review Commission, which "foresaw that by the year 2000 U.S. population would nearly double and overall demand for outdoor recreation would triple."

13. *1964 Annual Report of the Tennessee Valley Authority*, 17. For more information regarding Land Between the Lakes, see Frank E. Smith, *Land Between the Lakes; Experiment in Recreation* (Lexington: University Press of Kentucky, 1971), introduction by Roderick Nash. For an excellent historical overview of the LBL region, see J. Milton Henry, *The Land Between the Rivers* (Taylor Publishing Company, 1970). A more critical review of the LBL project can be found in John Egerton, "TVA: The Halo Slips: The Land Between the Lakes Dispute," *Nation*, July 3, 1967. For in-depth research on this topic, please visit the Forrest C. Pogue Special Collections Library at Murray State University, Murray, Kentucky.

14. Tennessee Valley Authority, *A Guide to Land Between the Lakes* (Knoxville: TVA, 1992), 7.

15. *1963 Annual Report of the Tennessee Valley Authority*, 26.

16. *1965 Annual Report of the Tennessee Valley Authority*, 77–87. Also see Tennessee Valley Authority, *A History of the Tennessee Valley Authority* (Knoxville: TVA Information Office, 1983), 31.

17. Tennessee Valley Authority, *A History of the Tennessee Valley Authority*, 31.

18. *1964 Annual Report of the Tennessee Valley Authority*, 23–24, and Tennessee Valley Authority, *Fish and Wildlife: Valuable Natural Resources* (Norris, TN: TVA Fish and Wildlife Branch, 1963–64) 1–2.

19. Evans, interview, 18; Gordon Young, "Whatever Happened to TVA?," *National Geographic*, June 1973, 847. A sampling of newspaper headlines illustrate these growing environmental concerns: "TVA, The Spoiler," "A Slipping Halo," "Energy Demands Clashing with Environmental Crisis," "Pollution Agencies, TVA Draw Women's Fire," "Effects of 'Acid Rain' on Environment Are Shown," from Tennessee Valley Authority, *Index of TVA News* (Knoxville: TVA Technical Library, 1967, 1973, 1976).

20. Allan M. Winkler, "Overview: The 1960s and 1970s" in *Encyclopedia of American Cultural and Intellectual History*, volume II, ed. Mary Kupiec Cayton and Peter W. Williams (New York: Scribner, 2001), 1113–1121; http://www.ourdocuments.gov/doc.php?flash=true&doc=97 (accessed September 4, 2007); William H. Chafe, *The Unfinished Journey: America Since World War II* (Oxford: Oxford University Press, 1995), 230–232, 437.

21. Winkler, "Overview," 1113–1121; Godfrey Hodgson, *America in Our Time* (Garden City, NY: Doubleday & Company, Inc., 1976), 404.

22. Ibid.

23. Bruce J. Schulman, *The Seventies: The Great Shift in American Culture, Society, and Politics* (New York: The Free Press, 2001), xv.

24. Evans, interview, 19.

25. Tennessee Valley Authority, *Annual Report of the Tennessee Valley Authority* (1955; reprint, New York: Arno Press, 1969), 1–5.

26. *1969 Annual Report of the Tennessee Valley Authority*, 38–39; Tennessee Valley Authority, *TVA Handbook* (Knoxville: TVA Technical Library, July 1987), 130.

27. Tennessee Valley Authority, *TVA Handbook*, 130.

28. Tennessee Valley Authority, *The First Fifty Years: Changed Land, Changed Lives* (Knoxville: TVA, 1983), 168. Before 1969, an estimated forty thousand acres of land had been abused to provide coal for TVA.

29. Tennessee Valley Authority, *A History of the Tennessee Valley Authority*, 31.

30. Harry M. Caudill, *Night Comes to the Cumberlands: A Biography of a Depressed Area* (Boston: Little, Brown and Company, 1962), 318.

31. Ibid., 320.

32. Ibid., 321.

33. Tennessee Valley Authority, *A History of the Tennessee Valley Authority*, 31; Tennessee Valley Authority, *The First Fifty Years: Changed Land, Changed Lives*, 168–169. In 1966 Virginia passed a surface mining law; Tennessee followed in 1967 and Alabama and Georgia in 1969.

34. Tennessee Valley Authority, *The First Fifty Years: Changed Land, Changed Lives*, 181-187; Richard A. Couto, "New Seeds at the Grass Roots: The Politics of the TVA Power Program since World War II" in Hargrove and Conkin, *TVA: Fifty Years of Grass Roots Bureaucracy*, 249.

35. Tennessee Valley Authority, *A History of the Tennessee Valley Authority*, 37–38; Tennessee Valley Authority, *The First Fifty Years: Changed Land, Changed Lives,* 181–187.

36. Tennessee Valley Authority, *Nuclear Power in the Tennessee Valley* (Knoxville: Tennessee Valley Authority, 1978), 2–3; Tennessee Valley Authority, *The First Fifty Years: Changed Land, Changed Lives*, 43.

37. Tennessee Valley Authority, *OEDC Proud 50: Office of En-*

gineering Design and Construction Fiftieth Anniversary Commemorative Booklet (Knoxville: Tennessee Valley Authority, 1983), 28; "TVA—Moving on to the '90s 'in the Service of the People,'" *Inside TVA*, May 9, 1989.

38. "TVA—Moving on to the '90s 'in the Service of the People,'" *Inside TVA*, May 9, 1989.

39. Tennessee Valley Authority, *Evolution and Status of the TVA Power System* (Chattanooga: Office of Power and the Office of Nuclear Power, 1987), 35–41.

40. John B. Waters, "The TVA Nuclear Recovery Program" (unpublished paper, Tennessee Valley Authority, Knoxville, TN, March 1993), 1.

41. Tennessee Valley Authority, *The First Fifty Years: Changed Land*, Changed Lives, 45.

42. Waters, "TVA Nuclear Recovery Program," 2.

43. Tennessee Valley Authority, *Evolution and Status of the TVA Power System*, 39. TVA completed three units at Browns Ferry and two units at Sequoyah. One unit is complete at Watts Bar Nuclear Plant (WBNP), and the TVA Board of Directors unanimously approved completion of WBNP Unit 2 at the August 1, 2007, board meeting. Bellefonte Nuclear Plant never operated. The TVA Board of Directors in 1981 and 1982 deferred and cancelled the units planned for Hartsville, Yellow Creek, and Phipps Bend.

44. William Bruce Wheeler and Michael J. McDonald, *TVA and the Tellico Dam, 1936–1979* (Knoxville: University of Tennessee Press, 1986), 27.

45. North Callahan, *TVA: Bridge over Troubled Waters* (South Brunswick, NJ: A. S. Barnes and Co., 1980), 224.

46. Ibid., 225; Wheeler and McDonald, *TVA and the Tellico Dam*, 150. See also Jefferson Chapman, *Tellico Archaeology* (Knoxville: University of Tennessee Press, 1995).

47. Tennessee Valley Authority, *Annual Report of the Tennessee Valley Authority, Volume 1—Text* (Knoxville: Tennessee Valley Authority, 1976), 24.

48. Wheeler and McDonald, *TVA and the Tellico Dam*, 156–157.

49. Endangered Species Act of 1973 (16 U.S.C. 1531–1544, 87 Stat. 884), as amended—Public Law 93–205, approved December 28, 1973, repealed the Endangered Species Conservation Act of December 5, 1969 (P.L. 91–155, 83 Stat. 275). The 1969 act had amended the Endangered Species Preservation Act of October 15, 1966 (P.L. 89–669, 80 Stat. 926).

50. Tennessee Valley Authority, *The First Fifty Years: Changed Land*, Changed Lives, 161. Wheeler and McDonald, 208–212.

51. Ibid.

52. http://www.endangeredspecieshandbook.org/aquatic_rivers2.php, September 4, 2007.

53. Chafe, *Unfinished Journey*, 476.

54. Tennessee Valley Authority, *Annual Report of the Tennessee Valley Authority 1982* (Knoxville: Tennessee Valley Authority, 1983), 4, 9.

55. Ibid., 9.

56. Tennessee Valley Authority, *OEDC Proud 50*, 28.

57. *1982 Annual Report of the Tennessee Valley Authority*, 9.

58. Ibid, 2. TVA employment dropped from a peak of more than fifrty-three thousand in April 1981 to fewer than forty thousand by September 1982. The 1983 rate increase was 4 percent, the smallest increase in twelve years.

59. Tennessee Valley Authority, *Index of TVA News* (Knoxville: TVA Technical Library, 1985), no. 4460, November 21, 1985, 166062.

60. Tennessee Valley Authority, *1987 Annual Report of the Tennessee Valley Authority* (Knoxville: Office of Governmental and Public Affairs, 1988), 3.

61. "TVA Sets Course to Improve Focus, Efficiency," *Inside TVA*, April 27, 1988, 1.

62. Tennessee Valley Authority, *Annual Report of the Tennessee Valley Authority* (Knoxville: Tennessee Valley Authority, 1991), 1.

63. "TVA Reorganizes for Service, Quality," *Inside TVA*, January 8, 1991, 1–4.

64. "Biography of the Postmaster General," http://www.usps .com/history/rbioa.htm (accessed September 7, 2007).

65. Tennessee Valley Authority, *Annual Report of the Tennessee Valley Authority* (Knoxville: Tennessee Valley Authority, 1996), 7.

66. Ibid., 13, 18–19.

67. Tennessee Valley Authority, *Annual Report of the Tennessee Valley Authority* (Knoxville: Tennessee Valley Authority, 2005), 8–9.

68. Tennessee Valley Authority, *Annual Report of the Tennessee Valley Authority* (Knoxville: Tennessee Valley Authority, 1994), 8–9; Tennessee Valley Authority, *Annual Report of the Tennessee Valley Authority* (Knoxville: Tennessee Valley Authority, 1995), 11; "Shoreline Management Policy," http://www.tva.gov/river/landandshore/landuse_shore.htm (accessed September 20, 2007).

69. "Reservoir Operations Study," http://insidenet.tva.gov/org/ rcsource/ro/ros.htm (accessed September 20, 2007); "TVA Board Approves Reservoir Operations Study Preferred Alternative," http://www.tva.gov/news/releases/aprjun04/ ros_rod.htm (accessed September 21, 2007).

70. Tennessee Valley Authority, *TVA Handbook, 2007* (currently in draft format), 10.

71. Tennessee Valley Authority, *Strategic Plan 2007* (Knoxville: Tennessee Valley Authority, 2007); http://www.tva.gov/ stratplan/tva_strategic_plan.pdf (accessed September 17, 2007).

72. Knoxville *News-Sentinel*, April 1, 2006; Tennessee Valley Authority, *Strategic Plan 2007*, 5.

73. "TVA Board Approves New Land Policy," *Inside TVA*, http://insidenet.tva.gov/insidenetnews/insidetva/dec06/ land.htm (accessed September 17, 2007); "TVA Board Appoints Tom Kilgore as CEO," *TVA Today*, http://in sidenet.tva.gov/org/cao/communications/tvatoday/2006/ october06/13/update.htm (accessed September 17, 2007); "TVA Board Approves Strengthened 2007 Strategic Plan," *TVA Today*, http://insidenet.tva.gov/org/cao/communica- tions/tvatoday/2007/may07/31/ (accessed September 18, 2007); "TVA Board Approves Completion of Second Unit at Watts Bar Nuclear Plant," *TVA News Release*, http:// www.tva.gov/news/releases/julysep07/wbu2.htm (accessed September 17, 2007).

74. National Archives and Records Administration, "Index to Photographs for Guntersville Reservoir," RG 142, National Archives—Southeast Region, Atlanta, Georgia.

75. "'Photo by Billy Glenn'—His Work a Lasting Legacy of TVA Memories," *Inside TVA*, March 13, 1990, 6.

76. Jim Andrews, "A 'Kollarful' Career," *Inside TVA*, November 24, 1998, 8.

77. Jim Andrews, "'Valley Chronicler' Kollar Retires," *Inside TVA*, July 16, 2002, 8.

78. Andrews, "A 'Kollarful' Career," 8.

79. Ibid.

80. Ibid.

81. Ibid; Andrews, "'Valley Chronicler,'" 8.

82. Cletus Mitchell (manager, teleproduction and photography, TVA), discussion with the author, September 2007.

83. Ibid.

84. Ibid.

85. Ibid.

86. Tennessee Valley Authority, *Personnel Lists for Salary Policy Employees and Annual Trades and Labor Employees*, 1975, 1979, 1980, 1985, 1990, 1996.

87. "From President and CEO Tom Kilgore," TVA Today, http://insidenet.tva.gov/org/cao/communications/tvatoday/ 2006/october06/16/ (accessed September 17, 2007).

Bibliography

Unpublished Material

Evans, Paul L. Interview by Charles W. Crawford. Tape recording transcript. August 7, 1979. Mississippi Valley Collection, John Willard Brister Library, University of Memphis, Memphis, Tennessee.

Garn, Ralph Franklin. *Tributary Area Development in Tennessee: TVA's Changing Perspective*. Unpublished dissertation, University of Tennessee, 1974.

"Index to Construction Progress Negatives, Guntersville Reservoir." Record Group 142, National Archives—Southeast Region, Atlanta, Georgia.

Lartson, Ekem Amonoo. *Participatory Planning at the Grassroots: The Tennessee Valley Authority's Tributary Area Development Program*. Unpublished thesis, University of Tennessee, 1995.

Lynch, James M. *Earth First! vs. the Tennessee Valley Authority: Biases in the Coverage of Protest*. Unpublished thesis, University of Tennessee, 1999.

Mitchell, Cletus. Discussion with author. September 2007.

Nelson, Marshall Ted. *Public Land Divestiture: The Tennessee Valley Authority Land Review and Disposal Program*. Unpublished dissertation, University of Tennessee, 1985.

Rawson, George Edward. *The Process of Program Development: The Case of TVA's Power Program*. Unpublished dissertation, University of Tennessee, 1979.

Reines, Sean. "TVA's Land Between the Lakes Recreation Area: Source of Major Controversy." Unpublished paper, December 3, 1996.

Tennessee Valley Authority. Corporate Communications Photograph Files, Corporate Communications, TVA West Tower, Knoxville, Tennessee.

———. Historic Photograph Collection. Cultural Resources, TVA West Tower, Knoxville, Tennessee.

———. *Personnel Lists for Salary Policy Employees and Annual Trades and Labor Employees*, 1975, 1979, 1980, 1985, 1990, 1996.

Waters, John B. "The TVA Nuclear Recovery Program." Unpublished paper, Tennessee Valley Authority, March 1993.

Internet Sources

"Biography of the Postmaster General." http://www.usps.com/history/rbioa.htm (accessed September 7, 2007).

"Civil Rights Act (1964)." http://www.ourdocuments.gov/doc.php?flash=true&doc=97 (accessed September 4, 2007).

"Craven Crowell: Former Chairman of TVA." http://www.cravencrowell.com (accessed October 31, 2006).

Endangered Species Handbook. "Aquatic Ecosystems." http://www.endangeredspecieshandbook.org/aquatic_rivers2.php (accessed September 4, 2007).

Kilgore, Tom. "From President and CEO Tom Kilgore." *TVA Today*. http://insidenet.tva.gov/org/cao/communications/tvatoday/2006/october06/16/ (accessed September 17, 2007).

Mayshark, Jesse Fox. "TVA: The Craven Years." http://www.metropulse.com/dir_zine/dir-2001 (accessed October 10, 2006).

Tennessee Valley Authority. "About TVA, Providing Power in the Public Interest." http://www.tva.gov/abouttva/index.htm (accessed April 10, 2006).

———. "Energy Environment, Economic Development." http://www.tva.gov/abouttva/index.htm (accessed May 30, 2006).

———. "Mr. TVA." http://www.tva.gov/heritage/redwagner/index.htm (accessed April 10, 2006).

———. "Reservoir Operations Study." http://insidenet.tva
.gov/org/resours/ro/ros.htm (accessed September 20, 2007).

———. "Shoreline Management Policy." http://www.tva.gov/
river/landandshore/landuse_shore.htm (accessed September
20, 2007).

———. "Strategic Plan 2007." http://www.tva.gov/stratplan/
tva_strategic_plan.pdf (accessed September 17, 2007).

———. "The Global View." http://www.tva.gov/heritage/glo
balview/index.htm (accessed April 10, 2006).

———. "The Mountaintop Marvel." http://www.tva.gov/heri
tage/mountaintop/index.htm (accessed April 10, 2006).

———. "TVA Board Appoints Tom Kilgore as CEO." *TVA
Today*. http://insidenet.tva.gov/org/cao/communications/tv
atoday/2006/october06/13/update.htm (accessed September
17, 2007).

———. "TVA Board Approves Completion of Second Unit at
Watts Bar Nuclear Plant." *TVA News Release*. http://www
.tva.gov/news/releases/julysep07/wbu2.htm (accessed
September 17, 2007).

———. "TVA Board Approves New Land Policy." *Inside TVA*.
http://insidenet.tva.gov/insidenetnews/insidetva/dec06/
land.htm (accessed September 17, 2007).

———. "TVA Board Approves Reservoir Operations Study
Preferred Alternative." http://www.tva.gov/news/releases/
aprjun04/ros_rod.htm (accessed September 21, 2007).

———. "TVA Board Approves Strengthened 2007 Strategic
Plan." *TVA Today*. http://insidenet.tva.gov/org/cao/com
munications/tvatoday/2007/may07/31/ (accessed September
18, 2007).

———. "TVA on the New Frontier." http://www.tva.gov/heri
tage/jfk/index.htm (accessed April 10, 2006).

———. "TVA Today." http://insidenet.tva.gov/tvatoday (ac-
cessed October 16, 2006).

———. "When the World Came to TVA." http://www.tva
.gov/heritage/worldsfair/index.htm (accessed April 10,
2006).

Articles

Andrews, Jim. "A 'Kollarful' Career." *Inside TVA*, November 24,
1998, 8.

———. "'Valley Chronicler' Kollar Retires." *Inside TVA*, July 16,
2002, 8.

Born, R. C. "TVA's Future: It Will Differ Significantly from
the Past—An Interview with Chairman S. David Freeman."
Barrons, June 26, 1978, 11, 14, 16–18.

Brewer, Carson. "TVA: A Child of Controversy." *Knoxville
News-Sentinel*, 1981.

Brown, J. D. "TVA's Genesis and Legacy." *Public Power*, 42,
May/June 1983, 28–39.

Cameron, Juan. "The Unconventional Chief Who's Shaking
Up the TVA." *Fortune*, 100, July 6, 1979, 128–131.

Carlson, John B. "The Tellico Dam: Where Both Archaeologist
and a Government Agency Are Being Tested." *Early Man*,
Summer 1979, 3–11.

Durisch, L. L. "Southern Regional Planning and Develop-
ment." *Journal of Politics*, 26, February 1964, 41–59.

Egerton, John. "TVA: The Halo Slips: The Land Between the
Lakes Dispute." *Nation*, 205, July 3, 1967, 11–15.

Ekbladh, David. "'Mr. TVA': Grass-Roots Development, David
Lilienthal, and the Rise and Fall of the Tennessee Valley
Authority as a Symbol for U.S. Overseas Development,
1933–1973." *Diplomatic History*, Summer 2002, vol. 26, issue
3, 335–375.

Freeman, Richard M. "Creation, Recreation and Tumoil." *Ten-
nessee Law Review*, 49, Summer 1982, 687–697.

Freeman, S. David. "Something New Is Happening in the Ten-
nessee Valley." *Catalyst*, 7, no. 1 (1979): 10–14.

Hargrove, Edwin C. "History, Political Science and the Study
of Leadership." *Polity*, 36, no. 4 (2004): 579–593.

Hendershot, Mary K. "Condemned by TVA: Tennessee Valley
Residents Relive the Trail of Tears." *Southern Exposure*, 10,
July/August 1982, 58–61.

Kollar, Robert. "A Legacy of the Lens." *Inside TVA*, November 17, 1981.

Lanier, Linda K. "Tellico Dam Battle—It's Not Just a Snail Darter: It Started with a Three Inch Fish but Now a Lot of Other Issues Have Become Involved in Government's Forty Year Old Plan to Dam Another River." *U.S. News and World Report*, 87, September 17, 1979, 35–36.

Lyons, Douglas C. "After Fifty Years, TVA Is Still in Hot Water: Once Condemned as Socialist, the Biggest Public-works Program in the Nation Now Is Underfire from Its Customers." *U.S. News and World Report*, 94, May 23, 1983, 63–64.

McCraw, T. K. "Triumph and Irony: The TVA." *Proceedings of the IEEE*, 64 (9), September 1976, 1372–1380.

Mosher, Lawrence. "Reagan Can Shape TVA's Environmental Path When He Picks Its Next Director; Under David Freeman, the TVA Has Become an Environmental Pace Setter." *National Journal*, 15, October 22, 1983, 2158–2161.

Norman, Geoffrey. "When Eminent Domain Hit Home, TVA Taking of Land from the Ritchey Family for the Tellico Dam Project." *Esquire*, April 1983, 115–116.

O'Neill, Karen M. "Why the TVA Remains Unique: Interest Groups and the Defeat of New Deal River Planning." *Rural Sociology*, June 2002, vol. 67, issue 2, 163–182.

"'Photo by Billy Glenn'—His Work a Lasting Legacy of TVA Memories." *Inside TVA*, March 13, 1990.

Powledge, Fred. "Can TVA Change Its Spots?" *Audubon*, 85, March 1983, 60–75.

Rogers, Michael. "TVA Population and Removal: Attitudes and Expectations of the Dispossessed at the Norris and Cherokee Dam Sites." *The Journal of East Tennessee History* 67 (1995): 89–105.

Rook, Robert. "Race, Water, and Foreign Policy: The Tennessee Valley Authority's Global Agenda Meets 'Jim Crow.'" *Diplomatic History*, January 2004, vol. 28, issue 1, 55–81.

Tennessee Valley Authority reporters. *Inside TVA*, vol. 1 (November 1979–December 1980) through vol. 27 (January–December 2006).

Thilmany, Jean. "Sunshine in a Lamp." *Mechanical Engineering*, November 2005, vol. 127, issue 11, 10–167.

"Warm Greeting in Peaceful Valley for JFK." *Florence (AL) Times*, May 19, 1963.

Winkler, Allan M. "Overview: The 1960s and 1970s." In *Encyclopedia of American Cultural and Intellectual History, Vol. II*, edited by Mary Kupiec Cayton and Peter W. Williams. New York: Scribner 2001, 113–121.

Young, Gordon. "Whatever Happened to TVA?" *National Geographic*, 143, June 1973, 830–863.

Books

Callahan, North. *TVA: Bridge over Troubled Waters*. South Brunswick, NJ: A.S. Barnes and Co., 1980.

Caudill, Harry M. *My Land Is Dying*. New York: E. P. Dutton, 1973.

———. *Night Comes to the Cumberlands*. Boston: Little, Brown and Company, 1962.

Chafe, William H. *The Unfinished Journey: America Since World War II*. New York: Oxford University Press, 1986.

Chandler, William U. *The Myth of TVA: Conservation and Development in the Tennessee Valley, 1933–1983*. Cambridge, MA: Ballinger Publishing Company, 1984.

Chapman, Jefferson. *Tellico Archaeology*. Knoxville: University of Tennessee Press, 1995.

Clapp, Gordon R. *The TVA: An Approach to the Development of a Region*. Chicago: University of Chicago Press, 1971.

Clark, Regina W. et al. *A Guide to Land Between the Lakes*. Knoxville: Tennessee Valley Authority, 1992.

Consolidated Appropriations Act, 2005. Conference Report to Accompany H.R. 4818. Congressional Reports: H. Rpt. 108–792—Making Appropriations for Foreign Operations, Export Financing, and Related Programs for the Fiscal Year Ending September 30, 2005, and for Other Purposes.

Creese, Walter. *TVA's Public Planning*. Knoxville: University of Tennessee Press, 1990.

Daniel, Pete et al. *Official Images—New Deal Photography*. Washington, DC: Smithsonian Institution Press, 1987.

Davis, Keith F. *An American Century of Photography: From Dry Plate to Digital*. Kansas City, MO: Hallmark Cards, Inc., 1995.

Diamonstein, Barbaralee. *Visions and Images: American Photographers on Photography*. New York: Rizzoli International Publications, Inc., 1981.

Droze, William Henry. *High Dams and Slack Waters: TVA Rebuilds a River*. Baton Rouge: Louisiana State University Press, 1965.

Endangered Species Act of 1973 (16 U.S.C. 1531–1544, 87 Stat. 884) as amended—Public Law 93–205.

Freeman, S. David. *Energy: The New Era*. New York: Vintage Books, 1974.

Grant, Nancy. *TVA and Black Americans: Planning for the Status Quo*. Philadelphia: Temple University Press, 1990.

Green, Jonathan. *American Photography: A Critical History, 1945 to the Present*. New York: Harry N. Abrams, Inc., 1984.

Hargrove, Erwin C. *Prisoners of Myth: The Leadership of TVA, 1933–1990*. Princeton, NJ: Princeton University Press, 1994.

Hargrove, Erwin C., and Paul K. Conkin, eds. *TVA: Fifty Years of Grass Roots Bureaucracy*. Urbana: University of Illinois Press, 1983.

Henry, J. Milton. *The Land Between the Rivers*. N.p.: Taylor Publishing Company, 1970.

Hodgson, Godfrey. *America in Our Time*. Garden City, NY: Doubleday & Company, 1976.

Hubbard, Preston J. *Origins of the TVA: The Muscle Shoals Controversy, 1920–1932*. Nashville: Vanderbilt University Press, 1961.

Huxley, Julian. *TVA, Adventure in Planning*. London: The Architectural Press, 1945.

Leiter, Kelly, and Robert Kollar. *The Tennessee Valley: A Photographic Portrait*. Lexington, KY: University Press of Kentucky, 1998.

Kennedy, John F. *Public Papers of the Presidents of the United States, John F. Kennedy, Containing the Public Messages, Speeches, and Statements of the President, January 1 to November 22, 1963*. Edited by Warren R. Reid. Washington, D.C.: United States Government Printing Office, 1964.

King, Judson. *The Conservation Fight: From Theodore Roosevelt to the Tennessee Valley Authority*. Washington, DC: Public Affairs Press, 1959.

McNeill, J. R. *Something New Under the Sun: An Environmental History of the Twentieth-Century World*. New York: W.W. Norton & Company, 2001.

Moore, John R., ed. *The Economic Impact of TVA*. Knoxville: University of Tennessee Press, 1967.

Owen, Marguerite. *The Tennessee Valley Authority*. New York: Praeger Publishers, 1973.

Roberts, Marc J., and Jeremy S. Blum. "The Tennessee Valley Authority." In *The Choices of Power: Utilities Face the Environmental Challenge*. Cambridge, MA: Harvard University Press, 1981.

Rosenzweig, F. B. *International Center for Knoxville: From Idea to a Realization*. Knoxville: Tennessee Valley Authority, 1963.

Rothstein, Arthur. *Documentary Photography*. Boston, MA: Focal Press, 1986.

Schulman, Bruce J. *The Seventies: The Great Shift in American Culture, Society, and Politics*. New York: The Free Press, 2001.

Singleton, C., ed. *The Sixties in America*. Pasadena, CA: Salem Press, 1999.

Smith, Frank E. *Land Between the Lakes: Experiment in Recreation*. Lexington: University Press of Kentucky, 1971.

Swidler, Joseph C. *Power and the Public Interest: The Memoirs of Joseph C. Swidler*. Edited by Scott Harrison. Knoxville: University of Tennessee Press, 2002.

Szarkowski, John. *Mirrors and Windows: American Photography since 1960*. New York: The Museum of Modern Art, 1978.

Tennessee Valley Authority Act, 16 USC Section 831, 831c, 831d-831h-l, 831l-831ed.

Tennessee Valley Authority. *A History of the Tennessee Valley Authority*. Knoxville: TVA Information Office, 1983.

———. *A Proposal for a National Recreation Area: Between the Lakes Formed by Kentucky and Barkley Dams.* Knoxville: TVA Board of Directors, 1961.

———. *A Quality Environment in the Tennessee Valley.* Knoxville: Tennessee Valley Authority, 1970.

———. *Annual Reports of the Tennessee Valley Authority, 1963–1969.* Reprint, New York: Arno Press, 1969.

———. *Annual Reports of the Tennessee Valley Authority, 1970–1976.* Washington, D.C.: U.S. Government Printing Office, 1970–1976.

———. *Annual Reports of the Tennessee Valley Authority, 1977–2006.* Knoxville: TVA Information Office, 1977–2006.

———. *Answers to the Most Frequently Asked Questions about TVA.* Knoxville: TVA Information Office, 1998.

———. *Chattanooga Office Complex, Users Manual.* Chattanooga: TVA Office of Power & Engineering, 1985.

———. *Environmental Research and Development: Issues and Needs, 1985–1990.* Knoxville: TVA Environmental Research and Development Staff, 1984.

———. *Evolution and Status of the TVA Power System.* Chattanooga: Office of Power and the Office of Nuclear Power, 1987.

———. *Fish and Wildlife: Valuable Natural Resources.* Knoxville: TVA Environmental Research and Development Staff, 1963/64.

———. *Index of TVA News, 1963–1988.* Knoxville: TVA Technical Library, 1963–1988.

———. *Inside TVA.* Knoxville: TVA Office of Information, 1980–2006.

———. *International Visitors Center, Knoxville.* Knoxville: Newman's Creative Printing, n.d.

———. *Nuclear Power in the Tennessee Valley.* Knoxville: Tennessee Valley Authority, 1978.

———. *OEDC Proud 50: Office of Engineering Design and Construction Fiftieth Anniversary Commemorative Booklet.* Knoxville: Tennessee Valley Authority, 1983.

———. *Recreation.* Knoxville: Division of Reservoir Properties, 1970.

———. *Tennessee Valley Authority Handbook.* Compiled and edited by Debra D. Mills and Avis L. Jones. Knoxville: TVA Technical Library, July 1987.

———. *Tennessee Valley Authority Handbook.* Draft format. Knoxville: Tennessee Valley Authority, September 2007.

———. *The First Fifty Years: Changed Land, Changed Lives.* Knoxville: Tennessee Valley Authority, 1983.

———. *The TVA Chattanooga Office Complex.* Chattanooga: Tennessee Valley Authority, 1986.

Wallace, Betty J. *Between the Rivers: History of the Land Between the Lakes.* Clarksville, TN: Center for Biology, Austin Peay University, 1992.

West, Carroll Van. *Tennessee's New Deal Landscape: A Guidebook.* Knoxville: University of Tennessee Press, 2001.

West, Carroll Van et al. *The Tennessee Encyclopedia of History and Culture.* Nashville: Rutledge Hill Press, 1998.

Wheeler, William B., and Michael J. McDonald. *TVA and the Tellico Dam, 1936–1979: A Bureaucratic Crisis in Post-Industrial America.* Knoxville: University of Tennessee Press, 1986.

Willis, William F. *The First Decade: TVA's First Ten Years of Nuclear Power Plant Design and Construction Experience.* Knoxville: Tennessee Valley Authority, March 1, 1978.

Zinn, Howard. *The Twentieth Century: A People's History.* New York: Harper Collins, 1998.

For Further Reading

This volume provides a very brief overview of the Tennessee Valley Authority (TVA) from 1963 to the present—a historical context in which to place the photographs. Much has been written about TVA in the past seventy-five years, but a considerable amount of that literature focuses on various aspects of the first thirty years of the agency.

For the later history of TVA, one of the best places to start is *TVA: Fifty Years of Grass Roots Bureaucracy*. Published during the agency's fiftieth anniversary in 1983, this volume, edited by Paul Conkin and Erwin Hargrove, is a series of articles about various aspects of the agency, including its formative years, leadership and government, contemporary problems, and TVA and American democracy. The essays provide a selective but quite informative picture of the agency and some of its problems, such as the issues with fossil-fuel plants and the construction of Tellico Dam. In fact, several of the contributors to this work went on to expand their articles into monographs—most notably Erwin Hargrove, who detailed his look at TVA leadership in *Prisoners of Myth: The Leadership of TVA, 1933–1990*, and Bruce Wheeler and Michael McDonald, whose *TVA and the Tellico Dam, 1936–1979: A Bureaucratic Crisis in Post-Industrial America* provides an in-depth study of the agency's decision to build Tellico Dam and the controversies that ensued.

For a comprehensive summary of the litigation aimed at stopping the construction of Tellico Dam, see Kenneth M. Marchison's *The Snail Darter Case: TVA Versus the Endangered Species Act*. This particular volume focuses on *TVA v. Hill* (1978), which was the Supreme Court's first interpretation of the Endangered Species Act of 1973.

Providing a look at the agency's environmental history is TVA's 1983 published report on the state of the region's environment entitled *The First Fifty Years: Changed Land, Changed Lives*. While out of print, this volume is an excellent review of what happened to the environment in the Tennessee River Valley between 1933 and 1983. The report defined the environmental conditions of the 1980s, but also identified critical environmental problems for the future, such as air quality.

Congress created TVA to provide flood control, navigation, and cheap electricity to the people of the Tennessee Valley. One of the better analyses of the utility's role in the valley is given in Gordon Clapp's book *The TVA: An Approach to the Development of a Region*. Clapp rose through the ranks to become chairman of the agency, and his perspective is especially insightful. In his book *Land Between the Lakes: Experiment in Recreation*, Frank E. Smith, TVA director from 1962 to 1972, provides an insider's view of the development of TVA's former national recreation area.

A more recent look at TVA as a development agency is *The TVA Regional Planning and Development Program: The Transformation of an Institution and Its Mission* by Aelred Gray and David Johnson. Gray was one of the planners hired in the beginning years of the agency, and this study examines the agency's regional development programs over seventy years: how they were related, the type of organization used, and the professional staffs which largely determined the scope of the regional programs.

Another very good look at TVA's regional development is Walter Creese's *TVA's Public Planning: The Vision, the Reality*. As part of its development approach, the agency altered the landscape with its massive dams, fossil-fuel plants, and nuclear plants. Tim Culvahouse's edited volume *Tennessee Valley Authority: Design and Persuasion* provides a fresh look at the agency's architecture and design. This series of essays on TVA architecture, landscape architecture, graphic design, industrial design, and the

fine arts illustrates TVA's role in modern American architecture and design.

With the approaching seventy-fifth anniversary of Franklin Delano Roosevelt's New Deal, scholars are taking a fresh look at some of the policies and programs of that time, including FDR's conservation, or environmental, policies. One such work is *FDR and the Environment*, edited by David Woolner and Henry Henderson. This book takes a fresh look at the New Deal and the environment and contends that the policies of the New Deal helped establish the foundation of the modern environmental movement. Another excellent study in this vein is Sarah Phillips's *This Land, This Nation: Conservation, Rural America and the New Deal*. Phillips devotes a chapter to TVA's farming and conservation policies, but she also writes in her epilogue about exporting the New Deal and the international contributions made by TVA and other New Deal programs.

And finally, to gain a more critical view of TVA, see William Chandler's *The Myth of TVA: Conservation and Development in the Tennessee Valley, 1933–1983*. Chandler challenges the perception that the agency's work involving navigation, flood control, and hydroelectric power created economic prosperity in the Tennessee Valley. Chandler argues that, instead of really helping the valley, TVA actually hindered economic growth.

While TVA has been studied and critiqued since the 1930s, there is much scholarship yet to do regarding this unique American agency.

Index

Agency for International Development (AID) (U.S.), 48
Air quality, 11, 22, 73
Allen Fossil (Steam) Plant, 151
Apalachia Reservoir, 47
Archaeological resources, 16–18, 56, 115; University of Tennessee, 16–17, 56
Asheville, N.C., 65
Ash hoppers, 167
Athens, Ala., 12

Baxter, Bill, 23
Bellefonte Nuclear Plant, 29–30
Bicentennial Volunteers, 84
Biothermal laboratory, 80
Birdwing pearly mussel, 104
Blizzard of 1993, 137
Blue Spring, Tenn., 6
Bonds, 129
Boone Reservoir, 54
Bottom ash, 146
Bottorff, Dennis, 23
Browns Ferry Nuclear Plant, 12, 13, 15, 24, 27–28, 52, 80
Bull Run Fossil (Steam) Plant, 11, 41, 94, 153
Buser, Lisa Waddell, 151
Bush, George W., 33
Butler, Tenn., 112

Casper, Wyo., 98
Caudill, Harry, 10–11

Central Laboratory, 158
Chattanooga, Tenn., 5, 59, 74, 113, 118, 122, 136, 158
Chattanooga Area Regional Transportation Authority (CARTA), 136
Chattanooga Office Complex, 113
Cherokee Indians, 16–18, 70
Chickamauga Reservoir, 93
Chota, 16, 70
Church Hill, Tenn., 111
Civil Rights Act of 1964, 9
Claiborne County, Tenn., 37
Clapp, Gordon, 24
Clean Air Act (1970), 11, 22
Clean Water Initiative, 22
Clifton, Tenn., 75
Clinch Powell Educational Cooperative, 60
Clinch River, 119, 152
Coal, 10, 13, 94, 157, 168
Coalfield, Tenn., 132
Columbia, Tenn., 68
Columbia Dam, 68, 104
Commercial Appeal, The (Memphis), 28
Community partnerships, 132, 146
Congressional tour, 55
Consolidated Appropriations Act of 2005, 24
Construction progress negatives, 25
Corinth, Miss., 97
Corum, Raymond "Steve," 31

Crawford, Otis, 31
Crowell, Craven, 145
Cumberland Fossil (Steam) Plant, 123, 167

Dean, Charles H. "Chili," Jr., 20, 100
Decatur, Ala., 131
Department of Defense (U.S.), 143, 162
DePriest, Don, 23
Deregulation, 22
Dogwood Arts Festival Parade, 25
Douglas Dam, 28
Douglas Reservoir, 126
Drakesboro, Ky., 142
Duck River, 68, 82
Duncan, Mike, 23

Earth Day, 9
Economic development, 7–8, 17, 22, 150
Economy, 19, 99
Edison Electric Institute (EEI), 166
Electrical Design Office, 62
Electricity, 4, 5, 6, 10, 13, 24, 46, 67, 74, 83, 149
Electrostatic precipitators, 11
Elk release, 144
Employee count, 23, 62, 85, 99, 116, 118
Employee teams, 123, 128, 143, 151, 158, 160
Endangered Species Act, 17
Energy conservation, 13, 72, 83, 97, 113; Energy Saver Program, 106
Energy demand, 4, 10, 19, 74, 99, 100, 171
Energy Vision 2020, 22

Environmental Education Program, 66
Environmental Protection Agency, 9, 11, 80
Environmental Research Center, 107, 143;
 constructed wetlands facility, 161; hot
 gas decontamination unit, 162
Environmental Response Team, 160
Etnier, David, 17
Evans, Paul, 5, 9
Express buses, 88

Federal appropriations, 23, 145
Fenton, Ky., 6
Fertilizer, 4, 6, 24, 48, 81, 107;
 concentrated superphosphate, 4
Fiber-optics, 122
Firefighters, 155
Fire Training Center, 173
Fish & Wildlife Management, 6, 8, 42, 43,
 119, 144
Flooding, 4, 5, 68, 111, 126
Forest Service (U.S.), 155
Fort Loudoun Dam, 17–18, 109
Freeman, David, 100
Freeman, Richard "Dick," 95, 100
Funding, 23–24

Gallatin Fossil (Steam) Plant, 146
Glenn, Billy H., 27–28
Golden Pond, Ky., 6, 38
Graves, Bishop William, 23
Great Smoky Mountains Institute at
 Tremont (GSMIT), 170
Green Power Switch, 172, 175
Green River, 142
Guthe, Dr. Alfred, 56

Hales Bar Dam, 49
Harris, Skila, 23, 172
Hays, Tenn., 6
Hematite, Ky., 6
Hendersonville, Tenn., 146
Hiwassee Dam, 47
Houke, Hank, 161
Hughes, Mimi, 169
Huntsville, Ala., 3, 118
Hydrology Laboratory, 82
Hydro-modernizaton, 149

Industry, industrial development, 39, 150
Information line, 87
Inside TVA, 28, 30
International visitors, 4, 22, 36, 48, 95,
 109, 133, 163
Investment Recovery Program, 105

Jackson, Tenn., 159
Jefferson County, Tenn., 30
Job fairs, 118
Johnson City, Tenn., 8

Karns, Tenn., 106
"Keep America Beautiful" tour, 120
Kennedy, John F., 3, 4
Kentucky Reservoir, 8, 75
Kilgore, Tom, 24, 33
Kimmons, George, 100
Kingston Fossil (Steam) Plant, 31, 33, 73,
 124, 168
Knoxville, Tenn., 61, 62, 69, 71, 78, 86, 87,
 88, 100, 102, 118, 125, 138, 160, 165
Knoxville Utilities Board (KUB), 53
Knoxville Worlds Fair, 29, 102, 103
Kodak negatives, 25

Kollar, Robert, 28–30, 98, 101, 105, 124,
 138, 139, 144, 145, 152, 155, 160

Lake Improvement Plan, 131
Land Between the Lakes (LBL), 6–7, 31,
 45, 144, 145, 164
Land Policy, 24
Lilienthal, David, 29
Logo, 138
Luttrell, David, 97, 104

Madison, Ala., 46
Management Efficiency Teams, 123
Marcos, Imelda, 95
Marion County, Tenn., 44
Maury County, Tenn., 82
Melton Hill Lock, 57
Melton Hill Reservation, 76, 147
Mint Spring, Tenn., 6
Mitchell, Cletus, 30–31, 119, 126, 128, 131,
 137, 157, 168, 170, 172
Model, Tenn., 6
Morrell, Steve, 154
Multi-purpose reservoir system, 4
Muscle Shoals, Ala., 3, 24, 48, 50, 81, 107,
 143, 161, 162

Nashville, Tenn., 3
National Archives and Records
 Administration, 25
National Fertilizer and Environmental
 Research Center, 107
National Fertilizer Development Center
 (NFDC), 48, 81
Navigation, 4, 5, 57, 61, 157
Nickajack Cave, 44

Nickajack Dam, 49
Nickajack Reservoir, 92
Night Comes to the Cumberlands, 10
Nissan, 114
Normandy Dam, 68
Norris, Tenn., 82
Norris Dam, 27, 127
Nuclear energy, 13, 15, 22, 24
Nuclear exchange program, 163
Nuclear Regulatory Commission (NRC),
 15, 141

Oak Ridge, Tenn., 76
Ocoee, Tenn., 148
Ocoee River, 22, 148
Olympic games, 21, 22, 148

Paint Rock Refuge, 42
Paradise Fossil (Steam) Plant, 142
Paris, Tenn., 101
Patent and Trademark Office (U.S.), 161
Perspective, 28
Phipps Bend Nuclear Plant, 13–14, 105
Pickwick Dam, 117
Polk County, Tenn., 22
Pollution, 54, 58
Power Control Center, 74; Load Control
 Center, 171
Power distributors: Elizabethton (Tenn.)
 Electric, 137; Knoxville Utilities Board,
 53
Power rates, 13, 20, 116
Protesters, 38, 96, 139
Public lands, 120, 147, 154
Public listening sessions, public meetings,
 22, 101

Public safety officers, 50, 69
Public Works Appropriations Act of
 1964, 6

Raccoon Mountain Pumped Storage
 Facility, 79, 92
Randolph, Jennings, 110
Recreation, 6, 76, 130, 152, 164
Red Stone Arsenal, 3
Reduction-in-force (RIF), 99, 116, 118
Reforestation, 4
Reservoir Operations Center, 175
Reservoir Operations Study, 23
Resources Development Seminar, 2, 36
River, The, 111
River Forecast Center, 165
Rocky Mountain Arsenal, 143
Runyon, Marvin, 20, 21, 116, 129

Sansom, William "Bill," 23
Schmitt, Ron, 133, 149
Selective Catalytic Reduction System
 (SCR), 167
Sequatchie County, Tenn., 39
Sequatchie Valley, 51
Sequoyah Nuclear Plant, 13, 15–16, 30, 32,
 93, 128, 133
Shoreline Management (Initiative) Policy,
 22–23
Smith, Olden, 31
Smyrna, Tenn., 114
Snail darter, 17–18
Solar power, 97, 113
South Pittsburg, Tenn., 133
Spring City, Tenn., 77, 89
STAR 7, 156

Stewart, Alex, 26
Strip mining, 10, 37; reclamation, 11, 37
Student Environmental Action Coalition,
 139
Sulfur Dioxide Emission Limitation
 (SDEL), 73
Surgoinsville, Tenn., 14, 105

Tellico Dam, 16–18, 56
Tennessean, The (Nashville), 28
*Tennessee Valley: A Photographic Portrait,
 The,* 29–30
Tennessee Wildlife Resources Agency
 (TWRA), 119
Test-demonstration farms, 4, 40
Thrailkill, Howard, 23
Three Mile Island, 15, 96
Tishomingo, Miss., 40
Tishomingo County, Miss., 40
Total Quality Management (TQM), 124,
 150
Transmission lines, 30, 33, 46, 63, 64, 121,
 137, 153, 159, 166; electric high voltage
 (EHV) switchyard, 46
Tributary area development, 6–8, 60, 65
TVA police, 140, 154
TVA towers, 78, 138

Unified resource development, 4, 109
Upfront, 30
Uranium, 15, 98

Valley Adventure, 102, 103
Vehicles: electric, 136; hybrid, 170
"Voyage of the Valley," 131

Wagner, Aubrey "Red," 36, 86
Washington, D.C., 136, 145
Watauga Dam, 112
Water quality, 59, 152, 169
Waters, John B., 20, 131
Watts Bar Dam, 89
Watts Bar Fossil (Steam) Plant, 89

Watts Bar Nuclear Plant, 24, 77, 85, 89,
 139, 141
Watts Bar Reservoir, 42, 43
Wheeler Dam, 149
Widows Creek Fossil (Steam) Plant, 25,
 121
Wildland Fire Management Crew, 155

Williams, Barry, 140, 142, 143, 146, 150
Williams, Susan Richardson, 23
Willis, William "Bill," 96
Wilson Dam, 50
Wind turbines, 175

Yearout, Dan, 31